THE BRUINS
IN BLACK AND WHITE
1966 TO THE 21ST CENTURY

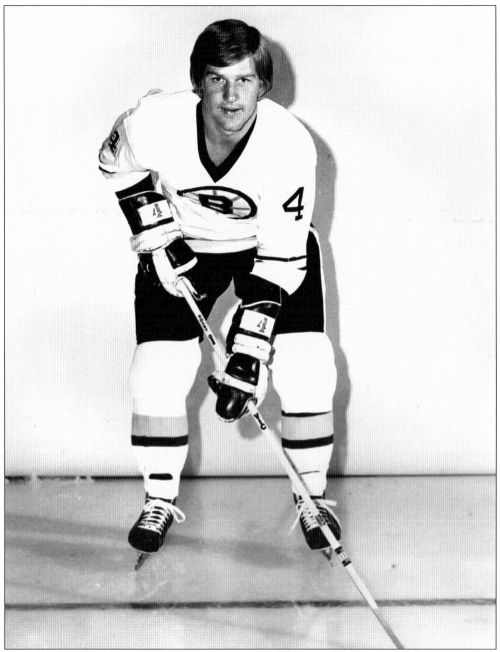

BOBBY ORR. The rookie sensation from Parry Sound would not only live up to the expectations the Bruins had for him, but he would revolutionize the way the game was played. (Photograph by Al Ruelle.)

THE BRUINS
IN BLACK AND WHITE
1966 TO THE 21ST CENTURY

Richard A. Johnson and Brian Codagnone

ARCADIA
PUBLISHING

Published by Arcadia Publishing
Charleston, South Carolina

Printed in the United States of America

Library of Congress Catalog Card Number: 2003115656

For all general information contact Arcadia Publishing at:
Telephone 843-853-2070
Fax 843-853-0044
E-mail sales@arcadiapublishing.com
For customer service and orders:
Toll-Free 1-888-313-2665

Visit us on the Internet at www.arcadiapublishing.com

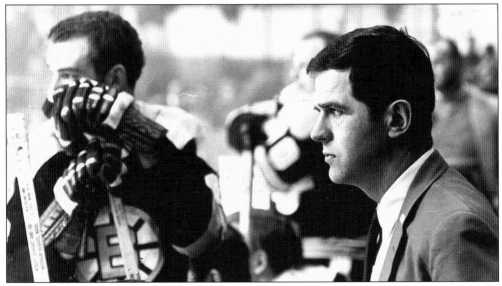

KEN HODGE AND HARRY SINDEN, 1966–1967. Ken Hodge (left) began his career with the Blackhawks, but his Chicago days were just a prelude to a stellar career. On May 15, 1967, he was involved in the greatest trade in Bruins history. The Bruins sent Gilles Marotte, Pit Martin, and Jack Norris to the Hawks for Phil Esposito, Ken Hodge, and Fred Stanfield. The deal was completed just before the rosters were frozen for the expansion draft. It turned out to be one of the most one-sided trades in National Hockey League (NHL) history; Esposito broke scoring records while helping to lead the Bruins to two Stanley Cups. Hodge and Fred Stanfield were major contributors to the Bruins' success in the early 1970s. Only Pit Martin had a career in Chicago, starring with the Hawks until 1977. Marotte played three seasons with the Hawks before moving on to Los Angeles, and Norris played only 10 games over two seasons. (Photograph by Al Ruelle.)

CONTENTS

ACKNOWLEDGMENTS

This project would have been impossible were it not for the yoeman effort of my coauthor, Brian Codagnone. He personifies the selfless code of old-time hockey and has been my winger on the Sports Museum "line" for many seasons. His knowledge of and enthusiasm for his beloved Bruins are evident on every page. We both undertook this two-volume project as a labor of love and have donated 100 percent of our royalties to the Sports Museum at Boston's FleetCenter, where we comprise the curatorial and facilties staff. The photographs and captions in this book are also the basis of an upcoming display within the museum.

We are grateful to Arcadia Publishing, especially associate publisher Tiffany Howe and former Arcadian Amy Sutton, for their support of our efforts.

We are also grateful to the Sports Museum staff, especially Michelle Gormley, as well as loyal staffers Adam Hansen and Sandra Rose, chairman Malcolm Graham, and our former executive director, Bill Galatis.

The Sports Museum would not exist at the FleetCenter were it not for the generous and thoughtful support of Richard Krezwick, Harry Sinden, Jim Bednarek, Steve Nazro, John Wentzel , David Splaine, Nate Greenburg, Mary Clivio, Amy Lattimer, John Mitchell, Jim Delany, Courtney McIlhaney, Roman "Rusty" Rustia, and the Jacobs family.

This book would not exist were it not for the collections made available to the museum from J. Harvey McKenney, Mike Andersen, John Ogasian, Fay Ruby, Mark Hauglie, Terence Doherty, Mac McDiarmid, Bill Swift, Steve Garabedian, Pam Schuyler-Cowens, Vera Vaughan, Milt Schmidt, the family of Walter Brown, and the late Dennis Brearley. Special thanks also go to Kevin Paul Dupont; Mark Torpey; Mary, Robert, and Elizabeth Johnson; John Cronin and Al Thibeault of the *Boston Herald*; Craig Campbell of the Hockey Hall of Fame; Michele Lee Amundsen; Barry Corbett; Tina Anderson; and the late Gordon Katz.

We are also grateful to the best team photographers in the business—namely, Al Ruelle and the father-son team of Steve and Brian Babineau. Their superb images come from decades of covering the Bruins better than any Frank Selke Award winner. This book would not have been possible without their generous assistance.

The Bruins staff was also invaluable in assisting with the production of this project. In particular, Nate Greenberg, Heidi Holland, Sue Byrne, and Ryan Nadeau were of tremendous help.

INTRODUCTION

The spoked B on the Bruins uniform crest, as designed in 1946 by *Record American* sports cartoonist Bob Coyne, is a clever graphic representation of an oft repeated quotation from Oliver Wendell Holmes Sr. in which he described Boston as "the hub of the universe." The logo has also come to symbolize both the hungry heart and lunchpail work ethic of a team whose style has characteristically been two-thirds ballet and one-third street fight.

From Shore to Orr to O'Reilly to Bourque to Thornton, the Bruins have maintained a consistency of graceful ruggedness and competitiveness. Unlike many star-driven franchises, the Bruins have been fortunate to have superstars who have adapted their game to that of the team and not vice versa. Over the past half-century, they have missed the playoffs only 12 times while capturing two unforgettable Stanley Cups (1970 and 1972).

In the years leading up to these cup victories, Boston was a hockey mecca in hibernation. Fans continued to fill all 13,909 seats at the Boston Garden, but all too often, the main attractions were opponents such as Rocket Richard, Jean Beliveau, Bobby Hull, Gordie Howe, and Frank Mahovlich. Despite the play of future Bruin Hall of Famers such as Allan Stanley, Ferny Flaman, John Bucyk, and Leo Boivin, the team suffered through a run of eight consecutive non-playoff appearances from 1960 to 1967. To make matters worse, this dismal streak corresponded directly with the unprecedented eight consecutive NBA championships captured by the Boston Celtics.

The old cliche about it always being darkest before the dawn was never more true than in regard to the Bruins. When word first arrived in the early 1960s that the team had discovered a 12-year-old phenomenon in Ontario named Bobby Orr, the press began to follow his progression through junior hockey. Stories about the Bruins' losses always seemed to include a note or two on the defenseman pegged as the franchise's savior-to-be.

The first rays of sunlight appeared in an exhibition game at the Boston Garden on the afternoon of December 5, 1964, when the Bruins brought their two affiliated junior hockey teams—the Niagra Falls Flyers and the Oshawa Generals—to Boston for an exhibition game. Not only did Bobby Orr dazzle the capacity crowd, but a brash center for the Flyers named Derek Sanderson did likewise, and Bruins fans openly speculated on a return to playoff glory once these two graduated to the big team.

Boston in the late 1960s was to sports what San Francisco was to the counterculture—a mecca with shades of nirvana. In the space of a week, one could watch Bill Russell, John Havlicek and company (there were good seats available), Carl Yastrzemski, Tony C, and the "Impossible

Dreamers," a hearty band of brothers known as the Boston Patriots, and hockey's Mozart—Robert Gordon "Bobby" Orr. It is impossible to imagine a better time and place in which to have been a sports fan.

A common trait of genius is that it is as easily recognizable as it is impossible to define or explain, and so it was with Bobby Orr. His arrival in Boston in the autumn of 1966 was nothing less than divine intervention for the most devoted fans of any franchise in North American professional sports. It had been exactly a quarter-century since the Boston Bruins had won a Stanley Cup, and Orr's arrival promised not only a return to glory but the presence of the most anticipated athlete to arrive in town since Bill Russell in 1956.

Not only was Orr a supremely gifted performer, but he was a leader as well. Like the greatest athletes, Orr made his teammates better and elevated every game in which he played. His injury-plagued tenure lasted only a decade but produced truly unforgettable results. Apart from trophy cases filled with hardware for team and individual honors, the Bruins were the franchise most responsible for the hockey boom in the United States.

Barely three years after Orr's departure to Chicago, the Bruins drafted Raymond Bourque in the wake of a heartbreaking overtime loss to Montreal in the seventh game of the division finals. With Bourque, the Bruins forged yet another link in the golden chain that encompasses their heritage. Bourque's powerful skating and rink-length rushes invited comparisons to those of Orr, and his gritty defensive play reminded old-timers of Eddie Shore and Lionel Hitchman.

In the years to follow, the Bruins not only beat the dreaded Montreal playoff jinx but made it to two Stanley Cup finals against the Edmonton Oilers (1988 and 1990). When their 29-year streak of consecutive playoff appearances ended in 1997, it marked the conclusion of the longest such streak in North American professional sports history. That same year, the Bruins struck gold with first-round draft choices Joe Thornton and Sergei Samsonov, and brighter days were soon to come.

To this day, the Bruins remain true to their roots in the consistent delivery of the hardest working teams in hockey. It is my hope and that of my coauthor, Brian Codagnone, that the images contained in this book help convey the competitive essence of America's oldest and most honored NHL franchise.

—Richard A. Johnson
November 2003

To Jeremy Jacobs, sportsman, philanthropist,
and Bruins owner since 1975.

To Harry Sinden, the ultimate Boston Bruin, who in nearly 40 years
with the team has served with class as coach, general manager, and president.

One

1966–1969

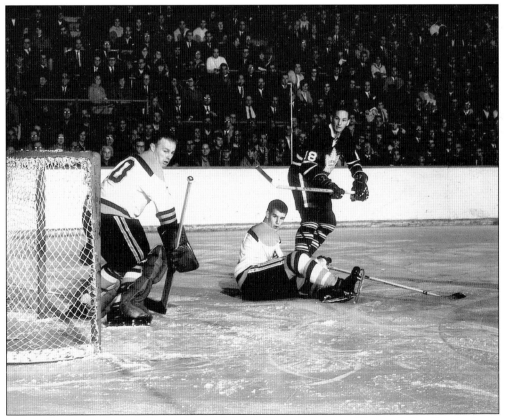

BOBBY ORR AND GERRY CHEEVERS AT MAPLE LEAF GARDENS. Toronto's Jim Pappin looks on as Orr protects the maskless Gerry Cheevers. Cheevers became famous as the first goalie to decorate his mask, adding stitches to mark where he would have been cut. (Courtesy of the Hockey Hall of Fame.)

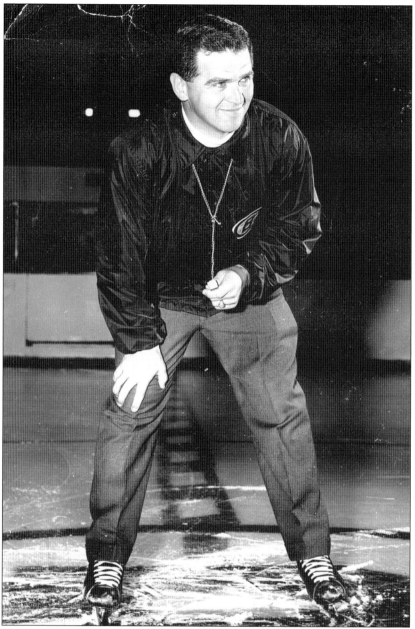

HARRY SINDEN. A premier amateur hockey player, Harry Sinden began in the Bruins organization in 1961 following a silver-medal-winning performance with Team Canada in the 1960 Olympics. After a coaching stint in Minneapolis, he became a player-coach in Oklahoma City in 1965, leading the club to the Central Hockey League (CHL) championship. He was named the Bruins' head coach in 1966, the same year that Bobby joined the club. After winning the Stanley Cup in 1970, Sinden surprised the hockey world by leaving coaching to pursue a business career. The lure of the game was too great, however. Asked to coach Team Canada in 1972, Sinden returned to the bench to lead the team to victory over the Soviet Union. After the series concluded, he returned to Boston to become the general manager and currently serves as president of the team. (Photograph by Al Ruelle.)

PIT MARTIN. In 1966–1967, Pit Martin was second in team scoring to John Bucyk, who had 48 points. Martin had 42 points on 20 goals and 22 assists, just one point ahead of Calder Award winner Bobby Orr.

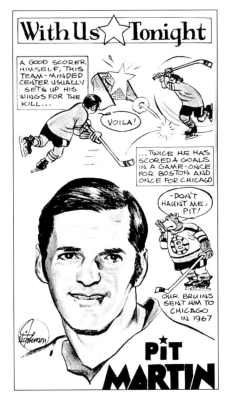

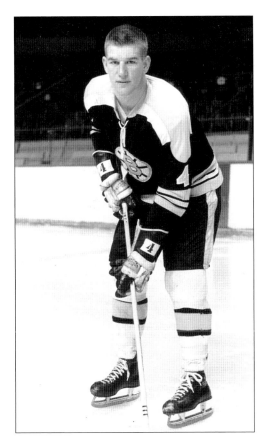

BOBBY ORR, TRAINING CAMP, 1967–1968. Sporting the redesigned Bruins uniform but still his old whiffle haircut, Bobby Orr stands poised to begin his second season in black and gold. The Bruins' jerseys were not the only thing new in the NHL that season. In 1967–1968, the league doubled its size, expanding from the "Original Six" to a coast-to-coast 12. (Photograph by Al Ruelle.)

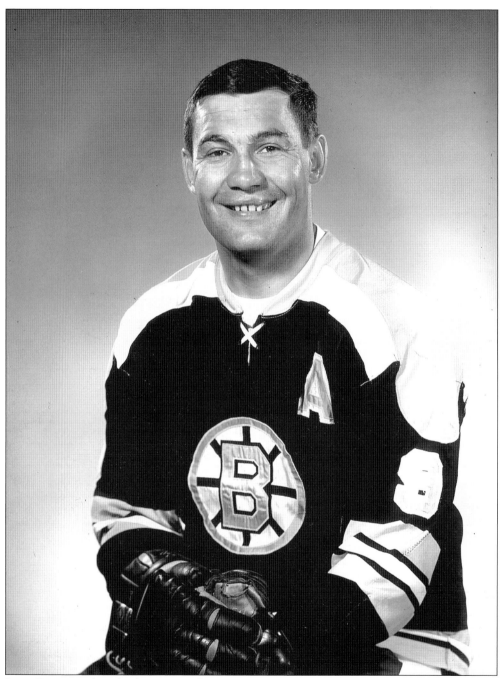

JOHN BUCYK. "The Chief" was named captain in 1966–1967 for his first tenure in that position. True to the Bruins' egalitarian spirit of the era, the team had no captain from 1967 to 1973, opting instead for three alternate captains (Phil Esposito, Ed Westfall, and Bucyk). Bucyk wore the captain's C from 1973 to 1977. (Photograph by Al Ruelle.)

JOHN MCKENZIE. John "Pie" McKenzie was a bronco-busting rodeo cowboy from High River, Alberta, who enjoyed a 22-year professional career in both the NHL and World Hockey Association (WHA). Pie was a Boston favorite while working the corners of the Boston Garden as a second-line right winger for seven seasons. (Photograph by Al Ruelle.)

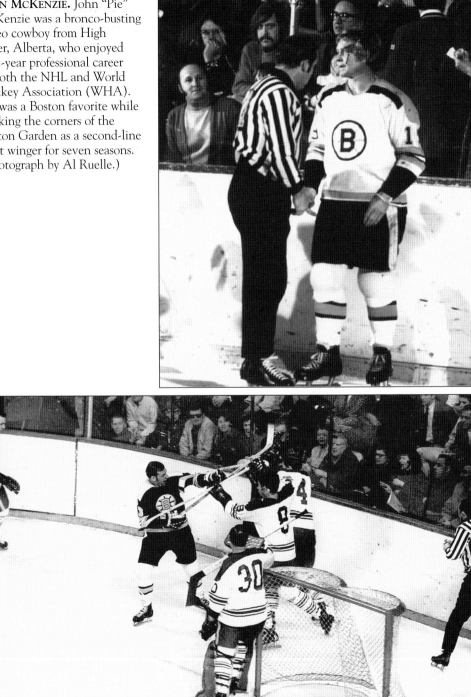

EDDIE SHACK. Always feisty, "the Entertainer" tussles with his old team. Shack was obtained from the Maple Leafs on the same night that assistant general manager Milt Schmidt made the trade for Esposito, Hodge, and Stanfield. Shack's wild antics sometimes masked the innate leadership and competitive fire that helped mold the Bruins into a solid unit. (Courtesy of Tim Killorin.)

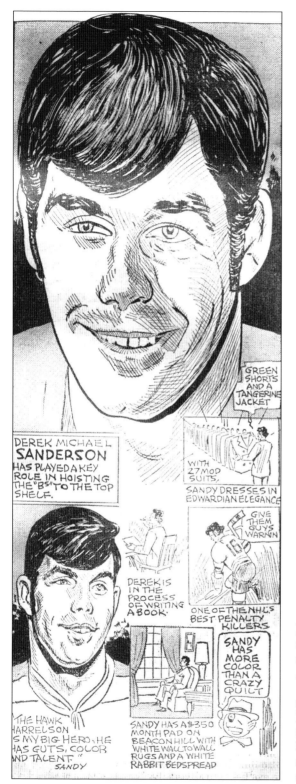

DEREK SANDERSON. One of the most colorful players to wear black and gold, Sanderson won the Calder Award as rookie of the year in the 1967–1968 season as he scored 24 goals and had 25 assists with the resurgent Bruins. Sanderson endeared himself to fans with his brilliant penalty killing, trademark poke checks, and willingness to fight anyone, anywhere. (Cartoon by Bob Coyne.)

ACTION AT THE FORUM. Bobby Orr wheels around Jean Beliveau in a game at the Montreal Forum. Beliveau was the leader of a Canadiens team that (although not the powerhouse it had been in the 1950s) was still a formidable rival for the Bruins in the late 1960s and the 1970s. (Courtesy of the Brearley collection.)

BOBBY ORR. *Sports Illustrated* rarely covers hockey, but Bobby Orr helped place hockey in the mainstream of American sports. The February 3, 1969, issue was published at a time when millions of television viewers were exposed to hockey through the almost weekly appearances by the Bruins on the CBS Sunday afternoon broadcasts. Orr also appeared on the *Sports Illustrated* cover as the 1970 Sportsman of the Year, the first hockey player so honored. That year, Orr led the NHL in scoring (the first defenseman to win a scoring championship), won the Hart Memorial Trophy as MVP, the James Norris Memorial Trophy as outstanding defenseman, the Conn Smythe Trophy as playoff MVP, and led the Bruins to their first Stanley Cup in 29 years. (Collection of the Sports Museum, donation from Mark Hauglie.)

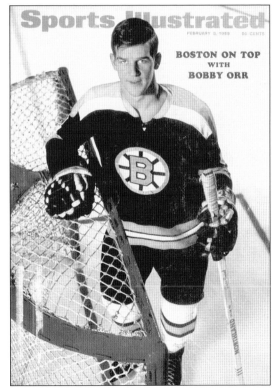

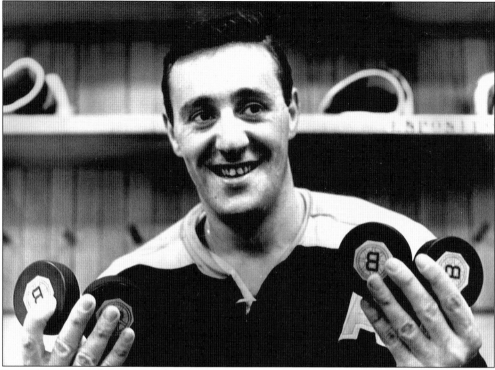

PHIL ESPOSITO. Almost immediately after arriving in Boston, Phil Esposito helped jump-start the Bruins back to the level of cup contenders with his 84-point season in 1967–1968. He is shown holding the pucks from his four-goal performance in the second home game of the season on October 15, 1967. Esposito scored 35 goals for the season. (Collection of the Sports Museum, photograph by Dennis Brearley.)

BOB WILSON. Bob Wilson began broadcasting Bruins games on the radio in 1964. After a brief stint in St. Louis, Wilson returned to Boston in 1971. Broadcasting with his deep voice and flawless diction, he was heard in most of North America due to the strong signal of WBZ radio. This cartoon captures Wilson's enthusiasm and goal call of "Scorrre!" He was inducted into the Hockey Hall of Fame in 1987 and retired with the Garden in 1995. (Courtesy of Richard A. Johnson.)

16

ED JOHNSTON. Ed Johnston backstopped the Bruins through the lean years of the early 1960s. He was the last goalie to play every minute of every game in a season, playing 4,200 minutes over 70 games in 1963–1964. The Bruins won 18 and lost 40 (with 12 ties), finishing last. (Cartoon by Vic Johnston.)

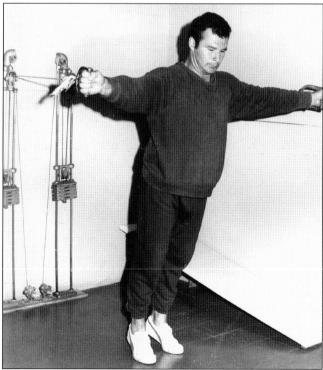

TED GREEN. "Terrible" Ted Green of Eriksdale, Manitoba, was so named for his ferocious play and tough nature. His battles with the likes of Lou Fontanato, John Ferguson, Reggie Fleming, and Howie Young are the stuff of legend. He is shown here training at the Colonial Health Club following his near-fatal skull fracture at the hands of Wayne Maki of the St. Louis Blues. His personal trainer at the Colonial was former Hungarian Olympian Gene Berde, the man who trained Carl Yastrzemski prior to his Triple Crown season in 1967. (Photograph by Al Ruelle.)

17

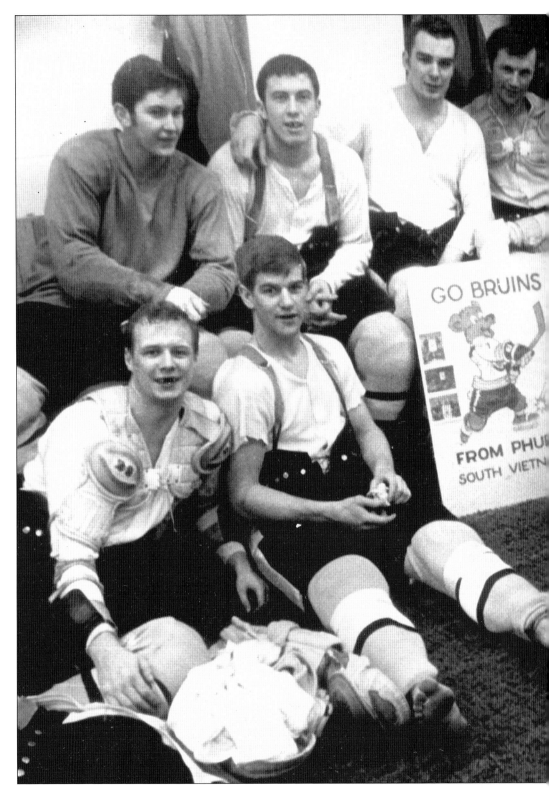

THE BRUINS RECEIVE GREETINGS FROM VIETNAM, 1969. Seen here are, from left to right, the following: (front row) Wayne Cashman, Bobby Orr, Glen Sather, Ed Westfall, Phil Esposito, John Bucyk, and trainer Dan Canney; (back row) Fred Stanfield, Don Awrey, Ken Hodge, Ron Murphy, John McKenzie, and trainer Frosty Forrestal. A close-knit group, these players formed the core of the Bruins dynasty of the early 1970s. Only Sather and Murphy did not play on the 1970 and 1972 Stanley Cup teams. (Courtesy of Dennis Brearley.)

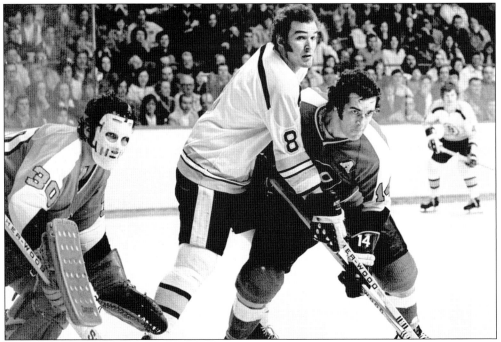

KEN HODGE, 1968–1969. The big winger scored 90 points on 45 goals and 45 assists in 1968–1969. Playing on a line with Phil Esposito and Wayne Cashman, Hodge would feed Esposito in the slot and shoot for power with a wicked slap shot. The combo was a major Bruins scoring threat in the 1960s and 1970s. (Collection of the Sports Museum.)

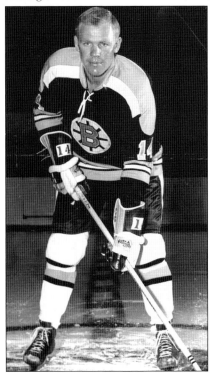

GLEN SATHER. Glen Sather, the future Edmonton Oilers and New York Rangers coach and executive, played for three seasons in Boston from 1966 to 1969. He scored 12 goals in 146 games and was lost in the postseason draft to Pittsburgh on June 11, 1969. (Photograph by Al Ruelle.)

THE BRUINS GO TO CHANNEL 38.
The 1967–1968 season marked the start of the Bruins' longtime relationship with television's channel 38, then known as WSBK. A new UHF station, the upstart channel scored a coup in securing the broadcast rights to the Bruins, who in a couple of seasons, would be the hottest ticket in town. The new UHF station broadcasted on a weaker signal than the established VHF stations did, however. In the era before cable and satellite television, fans bought elaborate antennae to capture the station's elusive signal. Don Earle served as the Bruins' television voice for four seasons before leaving to take the Flyers television post after the 1970–1971 season. He was succeeded by Fred Cusick, who would be known to a generation of fans as the television voice of the Bruins. (Courtesy of Richard A. Johnson.)

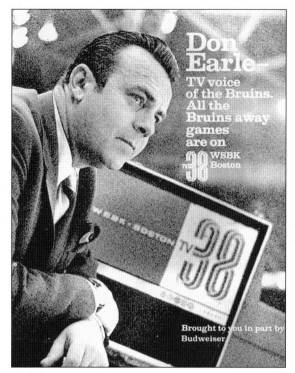

Don Earle — TV voice of the Bruins. All the Bruins away games are on WSBK Boston TV38

Brought to you in part by Budweiser

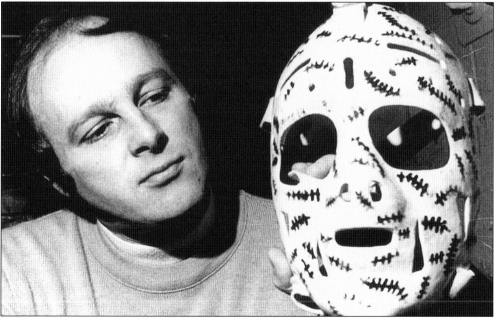

GERRY CHEEVERS AND HIS STITCH MASK. Gerry Cheevers admires the mask that prevented him from receiving all of the stitches represented on its surface. Cheevers was the first goalie to decorate his mask, painting stitches to mark where the mask saved him. Other goaltenders followed suit, with most masks bearing some distinctive styling. Today's hybrid cage-helmet masks did not end the practice. All mask decorating is done by professionals and can be quite elaborate. (Photograph by Pam Schuyler-Cowens.)

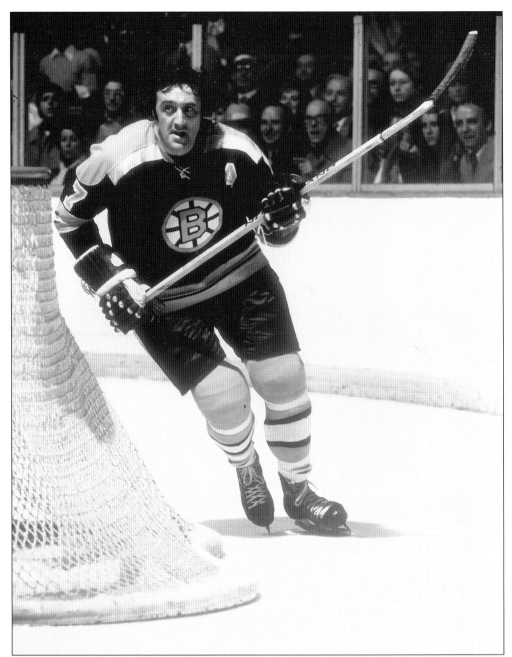

PHIL ESPOSITO REWRITES THE RECORD BOOKS. During the 1968–1969 season, Phil Esposito not only became the first NHL player to reach the 100-point plateau but ended up with an astonishing 126 points. He helped the Bruins to their first-ever 100-point season as the team finished in second place in the Eastern Division behind Montreal yet led the league with fewest defeats. In the playoffs, Esposito added another 8 goals and 10 assists in 10 games that included a sweep of the Maple Leafs and a heartbreaking six-game losing series against Montreal. (Courtesy of the Hockey Hall of Fame.)

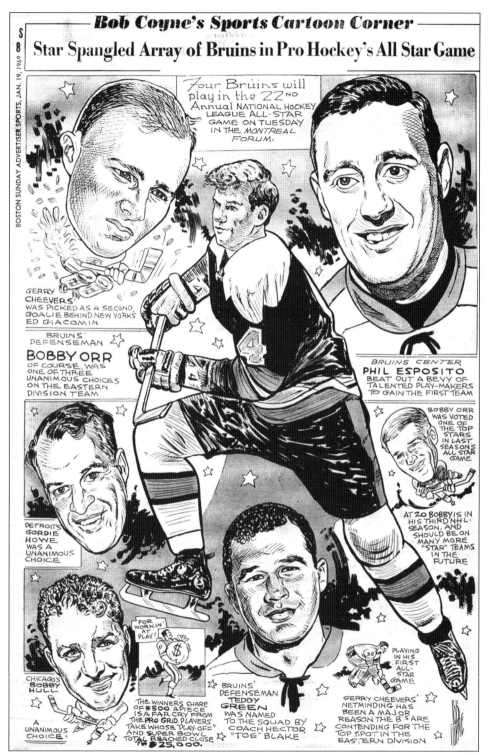

ALL-STARS. Bruins All-Stars for the All-Star Game at the Montreal Forum are shown along with NHL legends Gordie Howe and Bobby Hull. (Cartoon by Bob Coyne.)

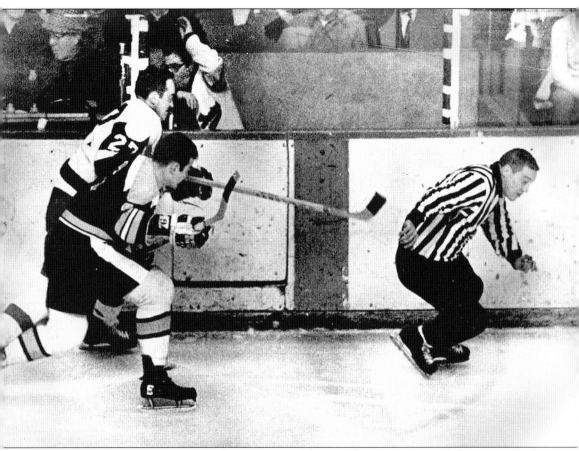

TED GREEN IN ACTION. Bruin defenseman Ted Green checks Red Wing left winger Frank Mahovlich in action at the Boston Garden as linesman Walt Atanas scurries to open ice. (Collection of the Sports Museum.)

Two

1970–1979

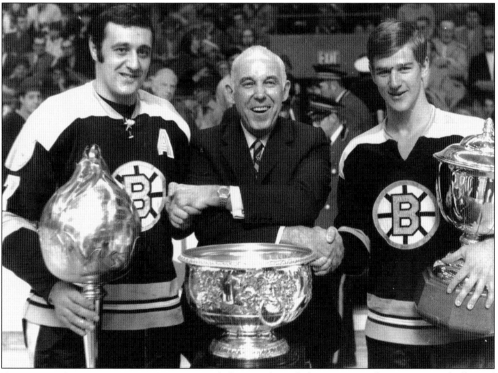

ESPOSITO, CAMPBELL, AND ORR. From left to right, Phil Esposito, Clarence Campbell, and Bobby Orr stand at the Boston Garden for an NHL trophy presentation. Campbell, the president of the NHL, presents Esposito with the first of the five Art Ross Trophies he captured during his career for leading the league in scoring and the first of the two Hart Trophies he captured as league MVP. Esposito shattered league scoring records in the 1968–1969 season when he became the first player to surpass 100 points with a 126-point total. Orr is shown holding the second of the eight Norris Awards he received during his career as the league's best defenseman. (Photograph by Al Ruelle.)

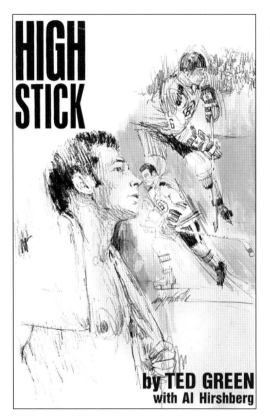

HIGH STICK, BY TED GREEN WITH AL HIRSHBERG. Ted Green told the story of his injury and comeback in this inspiring story. Green had to overcome brain damage and partial paralysis and learn to shoot from his opposite hand in order to return to the NHL. He not only played again against all odds, he was a team leader and a major contributor to the Stanley Cup win in 1972. (Courtesy of Richard A. Johnson.)

JOHNNY MCKENZIE. Johnny "Pie" McKenzie was a sparkplug of a player for the resurgent Bruins of the late 1960s and the big bad Bruins of the 1970s. Coming to the Bruins in a trade with the Rangers for tough guy Reggie Fleming in 1966, the right winger formed a line with Fred Stanfield and Johnny Bucyk and played on both Stanley Cup teams of the era (1970 and 1972). (Cartoon by Bill Robertson.)

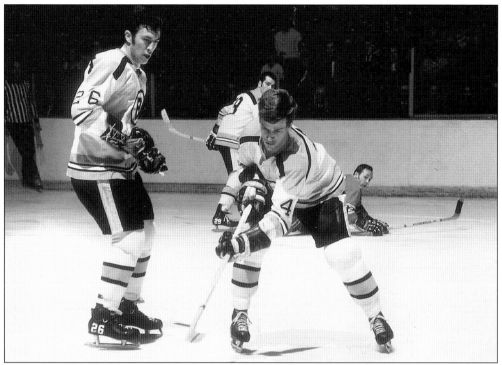

ORR CLEARS THE PUCK. Bruins Don Awrey (left) and Don Marcotte (center, back) along with Yvan Cournoyer of the Montreal Canadiens watch as Bobby Orr clears the puck from his zone in a game at the Montreal Forum. In the 1969–1970 season, the Canadiens, the Bruins' old nemesis, finished out of the playoffs as they lost their final game of the season to the division champion Chicago Blackhawks. For once, the road to the Stanley Cup did not run through the Forum. (Collection of the Sports Museum.)

PHIL ESPOSITO (LEFT), JOHN BUCYK (CENTER), AND BOBBY ORR. In a way, this picture sums up the Bruins' success in the 1970s. Take the superstar (Orr), the scoring machine (Esposito), and the veteran leader (Bucyk) and add the stellar goaltending of Gerry Cheevers and you have the basis of a dynasty. The dynasty would have lasted longer had the team not lost several key players to the World Hockey Association (WHA), including Cheevers, Derek Sanderson, Ted Green, and John McKenzie. (Collection of the Sports Museum.)

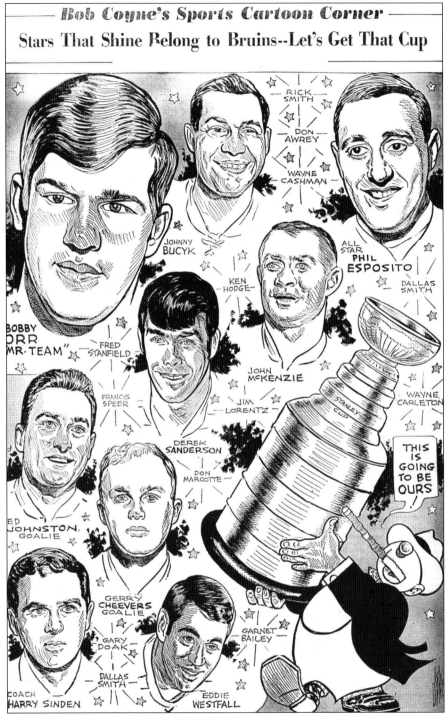

BRING ON THE RANGERS! Following their 99-point second-place finish behind the Blackhawks, the Bruins eagerly awaited their first-round playoff date with the New York Rangers. Both teams had rebounded at nearly the same time from nonplayoff status, and both franchises had last won Stanley Cups prior to the bombing of Pearl Harbor. (Cartoon by Bob Coyne.)

HARRY SINDEN'S SECRET WEAPON. The Bruins called up rugged defenseman Bill Speer in 1970 following Ted Green's injury. During the playoffs, the barber from Lindsay, Ontario, became a Boston folk hero as the result of several hefty body checks. (Cartoon by Bill Robertson.)

BOSTON BOMBER By Bill Robertson

BUMPIN' BILLY SPEER

GO AHEAD, HARRY— THROW IT AGAIN!

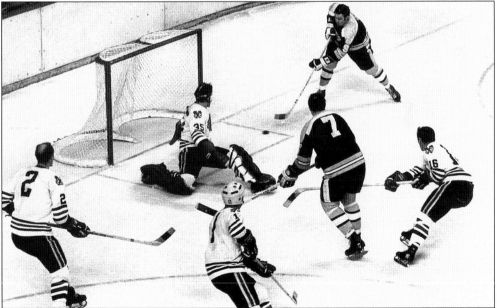

THE BRUINS SWEEP THE BLACKHAWKS, 1970. Seen here are, from left to right, Bill White, Tony Esposito, Doug Mohns, Phil Esposito, John Bucyk, and Chico Maki in action at the Boston Garden during the Bruins' sweep of the Blackhawks in the 1970 Stanley Cup semifinals. The Bruins outscored Chicago by an aggregate score of 20 goals to 10 to set up a final versus the expansion St. Louis Blues. (Collection of the Sports Museum.)

Bruins Seek 2nd Win Tuesday Night

Blues to Keep Shadow on Orr

Chief Topics By Bob Coyne

By PAUL LE BAR

ST. LOUIS (AP) — A defeat in the series opener notwithstanding, the St. Louis Blues say they plan to continue shadowing hockey's fabled Bobby Orr through the Stanley Cup finals.

Blues' Coach Scotty Bowman, his team blistered 6-1 by Orr's Boston Bruins' teammates Sunday, said the strategy will stick "right to the end."

"Why?" he asked. "Because when Orr's on the ice, he controls the game. I'd rather play their four against our two if Orr wasn't around."

Orr was harassed at every turn Sunday by St. Louis wings, causing the rest of the bruising Bruins to bide time until late.

Then Wayne Carleton flipped a shot over Ernie Wakeley's right foot with 4:59 gone in the third period for a 3-1 lead, and the Bruins were off.

Stocky left wing Johnny Bucyk rebounded a John McKenzie shot for his third goal and the prestigious hat trick 32 seconds later.

Increasingly less organized as the game opened up, St. Louis defenses were penetrated late by Derek Sanderson, who scored on a rink's length breakaway, and Phil Esposito, who scored unassisted.

Sanderson's goal was the only one assisted on by Orr, who commented, "I could have gone out for lunch."

"Naturally, I'd like more room," said Bobby, who was stalked by Blues' right wingers Jim Roberts, Tim Ecclestone and Terry Crisp.

"I didn't feel like I was doing very much out there, but I don't think they can afford to do what they were doing anymore."

"When they shadow Bobby," reminded Bucyk, "that's like giving 7 a 4-3 advantage."

Bucyk, enjoying one of his best of 15 seasons in the National Hockey League, had opened the Bruins scoring by firing past a screened Jacques Plante in the St. Louis net 15 seconds before the first period ended.

Roberts knotted the score at 1-1 in unleashing a shot past Bruins' goaltender Gerry Cheevers at 2:52 of the middle session before serious mishap struck the Blues.

A rising slap shot off the stick of center Fred Stanfield grazed the ps of Esposito on the way to the net and struck the masked Plante on the forehead.

He crumpled to the ice unconscious and was later taken to Jewish Hospital, where he was held for overnight observation. His condition was listed as satisfactory.

Wakely, a rookie netminder, spelled the 41-year-old Plante and was scored on 1:19 later by Bucyk. "He made the save," Bucyk said, "but it dribbled past him."

Bowman, who said he'd await a condition report today on Plante before selecting a goaltender for Tuesday night's second game in the best-of-7 series, absolved his scheme for stopping Orr of blame for the defeat.

"Roberts is the best at it," he said, "and we'll probably get better at what we're doing. We hope to get a whole lot better."

The Bruins, with seven straight playoff wins already under the belts, will try to add another Tuesday night when the teams resume their inal round in St. Louis.

Another win and the Bruins can head home for the Thursday and Sunday games at the Garden hoping for another sweep.

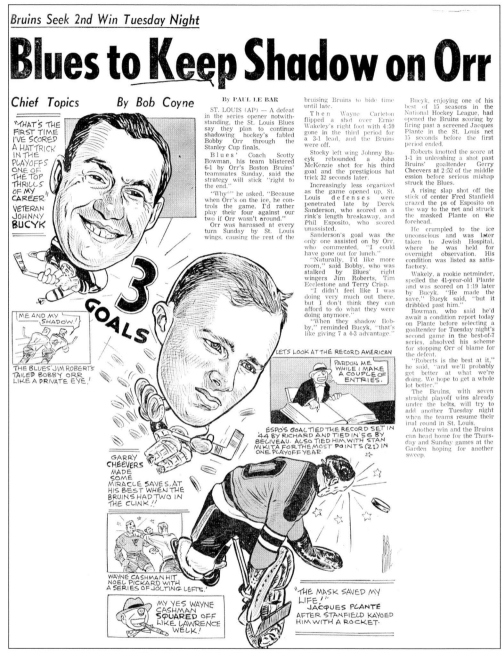

JOHN BUCYK SCORES A HAT TRICK. John Bucyk's hat trick paced the Bruins to a 6-1 victory in the first game of the Stanley Cup finals in St. Louis. A national television audience watched the Bruins completely outclass the Blues. (Cartoon by Bob Coyne.)

DEREK SANDERSON. Much to the delight of Bruins fans, Derek Sanderson allowed his skills and not his controversial "bad boy" antics to shine in the finals against the Blues. (Cartoon by Vic Johnson.)

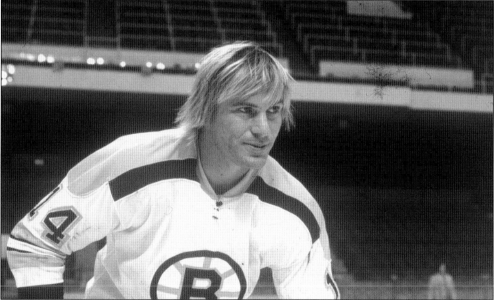

ACE BAILEY. Following a season-ending injury to forward Ron Murphy, the Bruins promoted Garnet "Ace" Bailey to regular duty. Bailey displayed flashes of brilliance before suffering a broken ankle against the Flyers on March 7 in a game at Philadelphia. In six seasons with the Bruins, the popular Bailey played for two Stanley Cup champions before being traded to Detroit for Gary Doak on March 1, 1973. Bailey died on an airplane on September 11, 2001, in the World Trade Center attacks. (Photograph by Al Ruelle.)

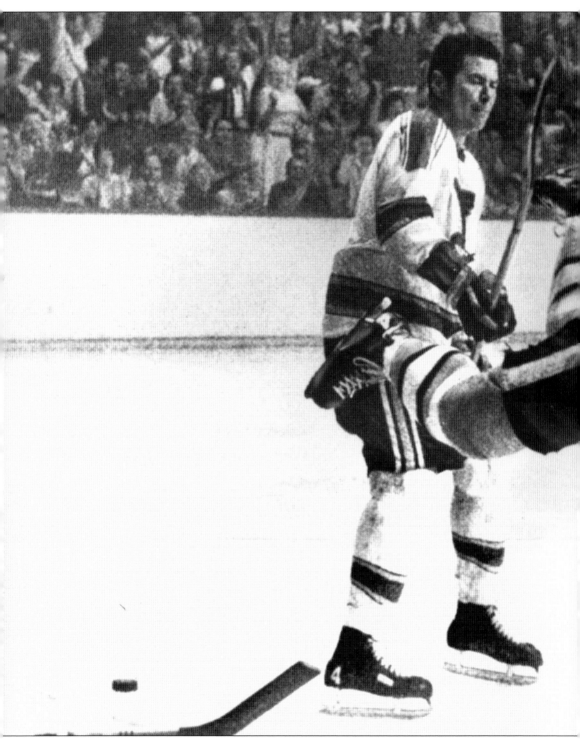

BOBBY ORR WINS THE STANLEY CUP. Forty seconds into overtime in a game against the St. Louis Blues, Bobby Orr took a behind-the-net pass from Derek Sanderson to score the winning goal in the 1970 Stanley Cup finals. Upended by Blues defenseman Noel Picard,

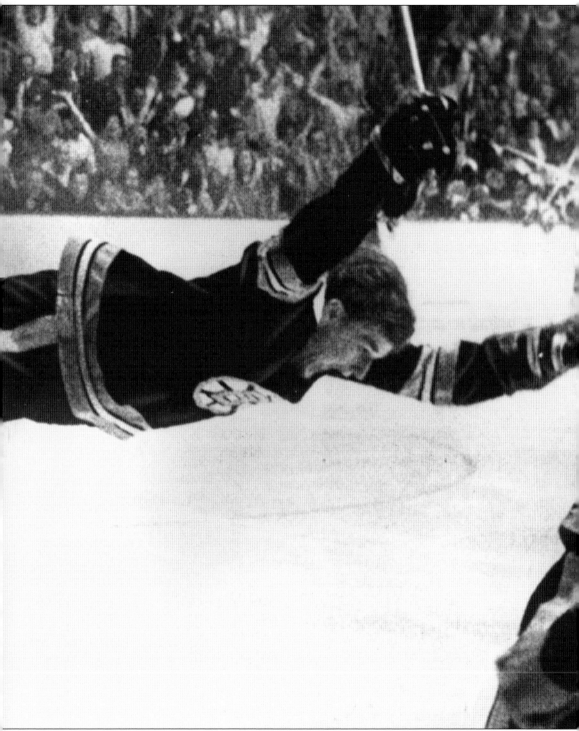

Orr literally flew through the air to create one of the most famous images in hockey history. (Photograph by Ray Lussier.)

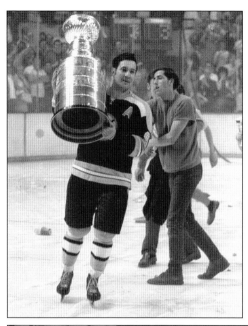

JOHN BUCYK CARRIES THE CUP ON THE BOSTON GARDEN ICE, MAY 10, 1970. Although the Bruins used three alternate captains instead of a captain and two alternates, Johnny Bucyk was the de facto captain of the team. In his 14th season as a Bruin, the player known as "Chief" has the honor of carrying the cup in front of the home fans. (Photograph by Al Ruelle.)

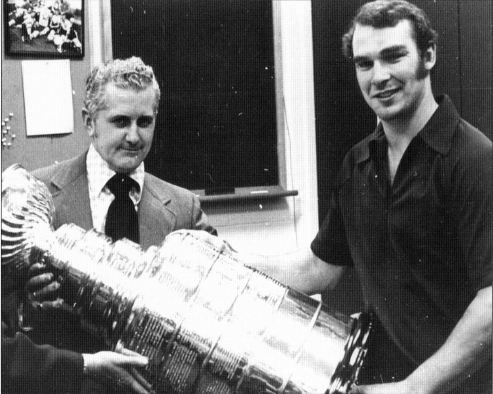

AL RUELLE AND KEN HODGE. Longtime Bruins photographer Al Ruelle (left) poses with Ken Hodge and the Stanley Cup. The cup returned to Boston after a 29-year absence, and for most of those years, Ruelle chronicled the team's ups and downs, stars, and journeymen. (Collection of Al Ruelle.)

A BRUINS LOCKER ROOM CELEBRATION. It had been 29 long years since the Bruins drank champagne from Lord Stanley's mug. On hand for the celebration was Milt Schmidt (left), a veteran of that 1941 team, shown hugging team owner Weston Adams Sr. (Photograph by Al Ruelle.)

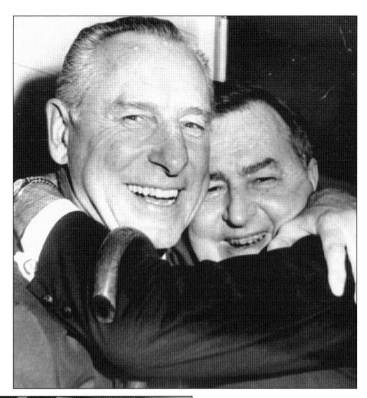

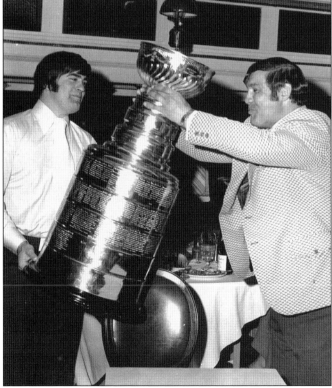

JOHNNY BUCYK AND WESTON ADAMS JR. Johnny Bucyk (right) shares the Stanley Cup with team executive Weston Adams Jr. prior to the largest civic celebration in Boston since the end of World War II. (Photograph by Al Ruelle.)

35

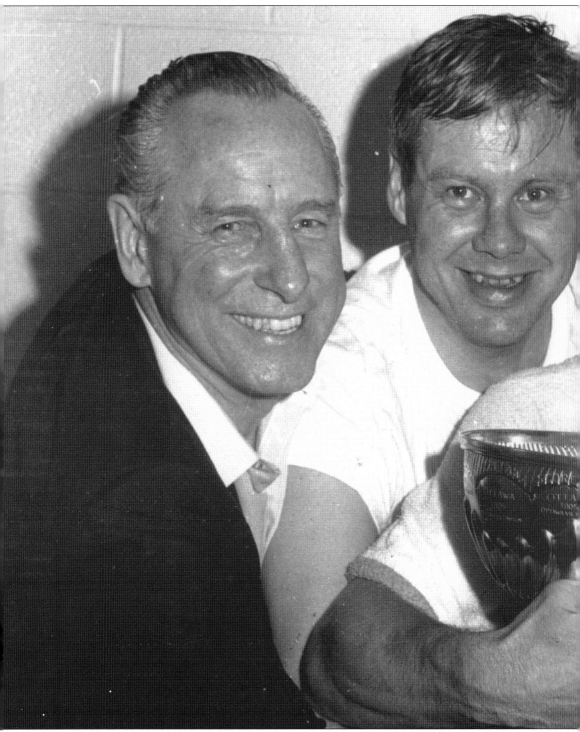

MILT SCHMIDT, TOM JOHNSON, BOBBY ORR, AND HARRY SINDEN. From left to right, Milt Schmidt, Tom Johnson, Bobby Orr, and Harry Sinden celebrate winning the Stanley Cup. Only Schmidt and Johnson already had their names inscribed on the cup prior to the Bruins'

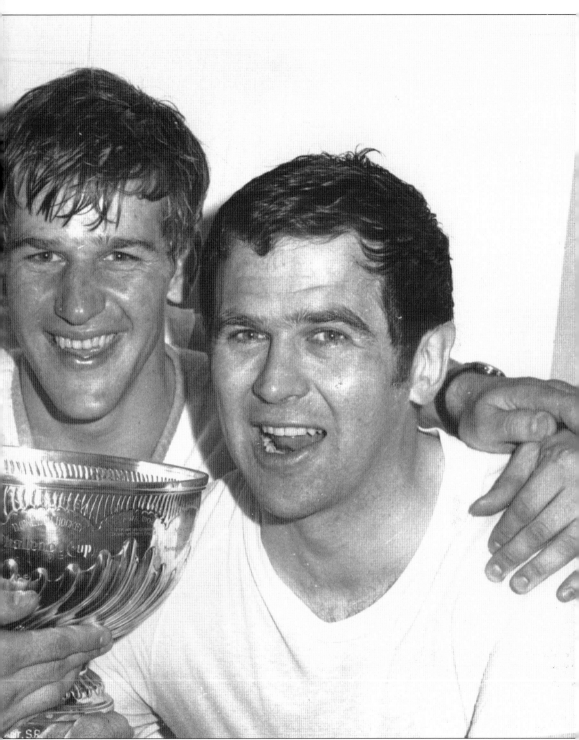

historic triumph. Within days, the Bruins organization announced the shocking news that Harry Sinden was leaving the team to pursue a business career with a housing manufacturer named Sterling Homex. (Photograph by Al Ruelle.)

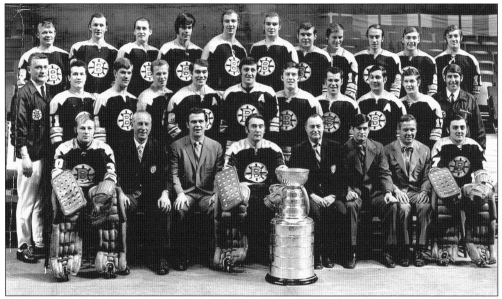

THE 1970 STANLEY CUP CHAMPIONS. Seen here are, from left to right, the following: (front row) Gerry Cheevers, general manager Milt Schmidt, coach Harry Sinden, Ed Johnston, Weston Adams Sr., Weston Adams Jr., Tom Johnson, and John Adams; (middle row) trainer Dan Canney, Bill Lesuk, Bobby Orr, Wayne Cashman, Eddie Westfall, Phil Esposito, Don Awrey, Don Marcotte, John Bucyk, Fred Stanfield, and assistant trainer John Forristall; (back row) John McKenzie, Ron Murphy, Dallas Smith, Derek Sanderson, Wayne Carlton, Ken Hodge, Bill Speer, Ace Bailey, Gary Doak, Jim Lorentz, and Rick Smith. (Collection of the Sports Museum.)

A STORYBOOK WITH A MYSTERY ENDING. (Cartoon by Bob Coyne.)

HARRY SINDEN LEAVES HOCKEY.
On May 14, 1970, Harry Sinden,
accompanied by Wynn G. Moseley,
a public relations representative
of Sterling Homex Corporation,
announced his departure from
the Bruins organization. Sinden's
resignation shocked Bruins fans
who had just finished celebrating
the Bruins' first Stanley Cup in 29
seasons. Sinden led the team from
last place to first in just four seasons.
(Collection of the Sports Museum.)

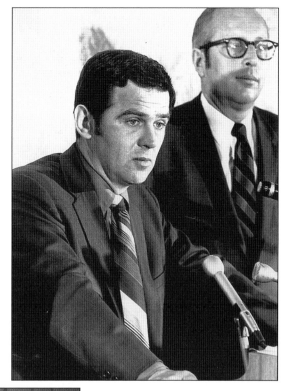

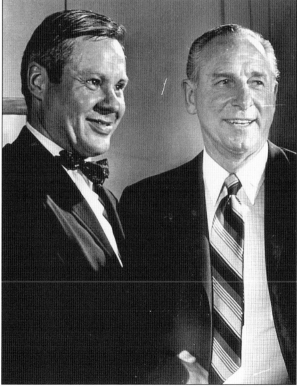

**MILT SCHMIDT AND TOM
JOHNSON.** Bruins general manager
Milt Schmidt (right) welcomes
the Bruins' new head coach, Tom
Johnson. Johnson, a former Hall
of Fame defenseman with the
Montreal Canadiens, inherited a
Stanley Cup championship team
that was also the most colorful
team in modern hockey history.
(Photograph by Frank Kelly.)

TO THE VICTORS GO THE SPOILS. The Bruins soon cashed in on as many opportunities as their Stanley Cup triumph would allow. No fewer than five Bruins signed book deals, and nearly everyone made personal appearances at everything from automobile dealership openings to county fairs. (Collection of the Sports Museum.)

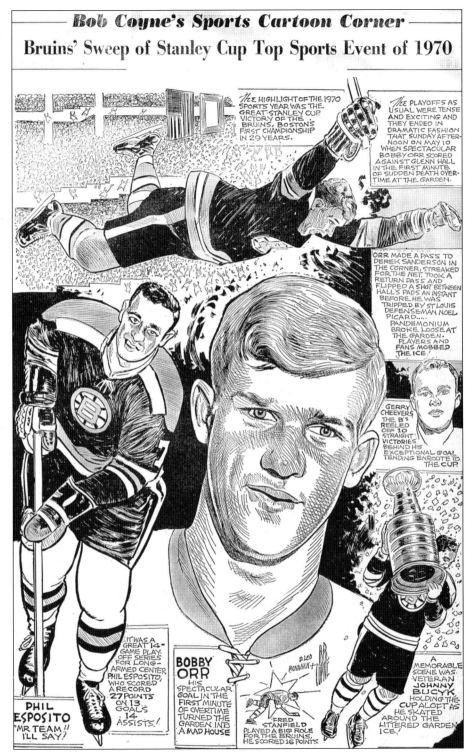

THE SPORTS EVENT OF THE YEAR. The Bruins' Stanley Cup victory was the obvious choice for sports event of the year, if not the decade. (Cartoon by Bob Coyne.)

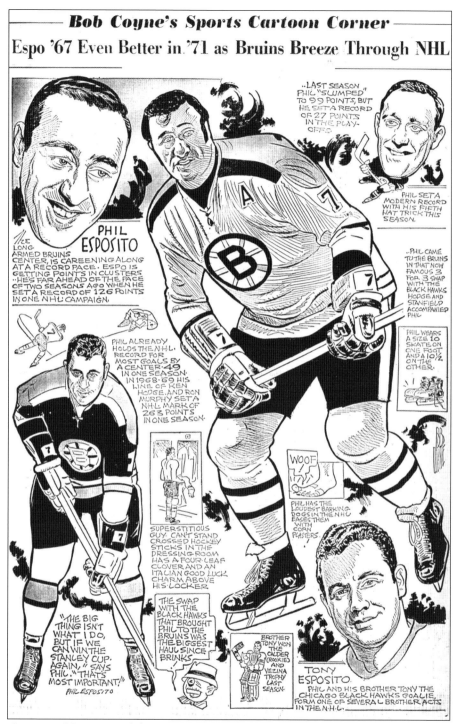

THE SCORING MACHINE. If the 1970–1971 Bruins were hockey's version of the "Murderer's Row" 1927 Yankees, then center Phil Esposito was their Babe Ruth. Esposito broke his own NHL scoring record with 152 points from a record 76 goals to match his 76 assists. (Cartoon by Bob Coyne.)

A STANDING OVATION FOR TED GREEN. Defenseman Ted Green receives a standing ovation from fans during the Bruins' 7-2 victory over the Montreal Canadiens in the final regular season game of the 1970–1971 season on April 4. Not only did the campaign mark the greatest regular season in team history, but Green was an inspirational leader, having recovered from a near-fatal skull fracture suffered in September 1969. (Photograph by Al Ruelle.)

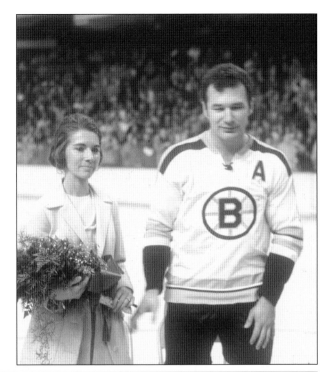

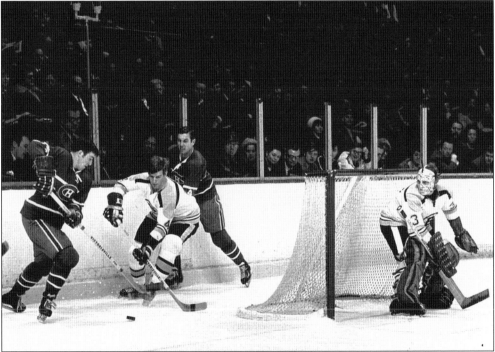

A PLAYOFF UPSET, 1971. Bobby Orr eludes Phil Roberto (left) and Jean Beliveau of the Montreal Canadiens in quarterfinal playoff action at the Montreal Forum as Gerry Cheevers guards the net. The seven-game upset victory by the 1971 Canadiens still ranks as one of the greatest disappointments in Bruins history. (Collection of the Sports Museum.)

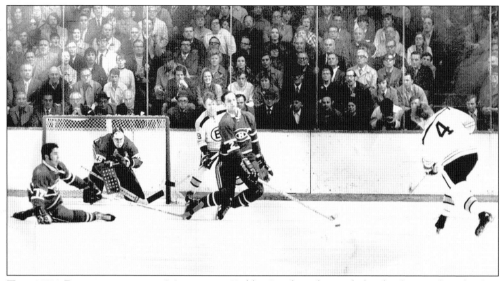

THE 1971 PLAYOFFS AGAINST MONTREAL. Bobby Orr fires the puck for the first goal in the first game of the Bruins' defense of their 1970 Stanley Cup. The Bruins won the first game on home ice by a 3-1 score but dropped four of the next six games, including the final two to lose their title. In the final two games, the Canadiens outscored Boston by a combined score of 12-5. Canadiens rookie goalie Ken Dryden proved the difference, as the former Cornell star stoned a Bruins offense that had tallied 399 goals during the regular season. (Collection of the Sports Museum.)

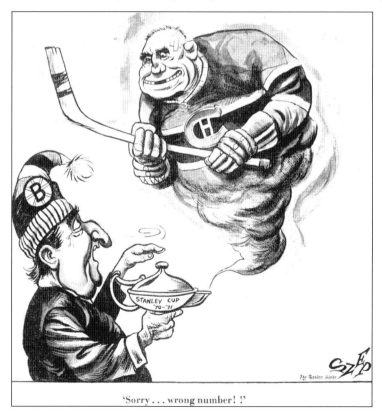

'Sorry . . . wrong number! !'

THE RIVALRY. For more seasons than most Bruins fans care to remember, the Montreal Canadiens have been the team's nemesis. (Cartoon by Paul Szep.)

TERRY O'REILLY. Terry O'Reilly sports the Bruins' new white home jersey. In 1972, he played a supporting role for the eventual Stanley Cup champions but missed the playoffs. In time, the hearty winger was recognized as one of the league's toughest players and a natural leader who led by example. (Collection of the Sports Museum.)

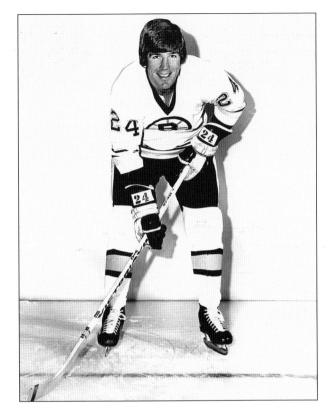

DAN CANNEY. Trainer Dan Canney toiled long hours to keep the 1972 Bruins on track for the Stanley Cup playoffs. The Charlestown native began working with the Bruins in 1963 and served the team as head trainer through the 1984–1985 season. (Cartoon by Bill Robertson.)

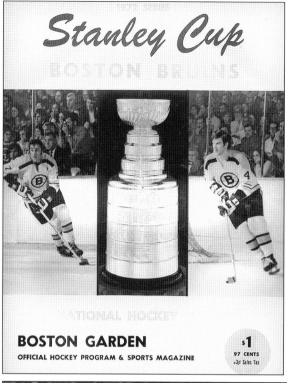

Stanley Cup

BOSTON BRUINS

BOSTON GARDEN
OFFICIAL HOCKEY PROGRAM & SPORTS MAGAZINE

$1
97 CENTS
+3¢ Sales Tax

A 1972 BRUINS STANLEY CUP PROGRAM. The Bruins finished the regular season with 119 points as the result of their 54-13-11 record. In the Stanley Cup playoffs, the Bruins lost only one game in three series of victories versus the Maple Leafs, Blues, and Rangers. (Courtesy of Richard A. Johnson.)

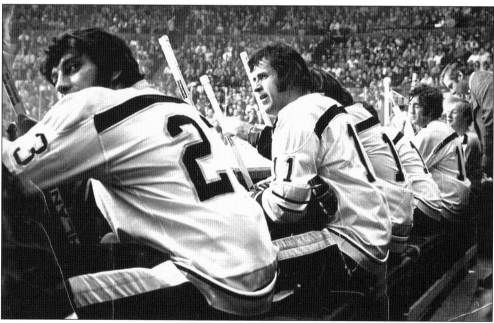

THE 1972 BRUINS ON THE BOSTON GARDEN BENCH. On the bench are, from left to right, Matt Ravelich, Mike Walton, Carol Vadnais, John McKenzie, Rick Smith, Wayne Cashman, and coach Tom Johnson. Following the harsh dissapointment of losing to the Montreal Canadiens in the playoffs the previous season, the Bruins bounced back against the New York Rangers to win their fifth Stanley Cup. (Photograph by Al Ruelle.)

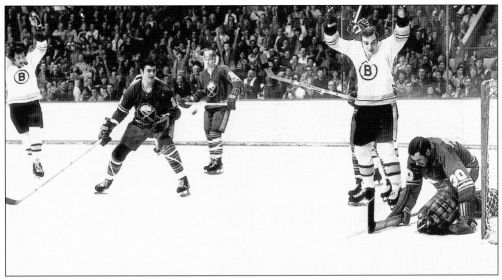

KEN HODGE SCORES HIS 100TH POINT. Ken Hodge celebrates the goal that clinched his 100th point, which took place in a game versus the Sabres and goalie Roger Crozier at the Boston Garden in March 1971. In 10 seasons with the Bruins, the rugged right winger scored 289 regular-season goals as well as 34 playoff goals. (Photograph by Frank Hill.)

A NEW ENGLAND WHALERS PROGRAM. This October 1972 program features captain Ted Green. The upstart Whalers shared the Garden ice with the Bruins before eventually relocating to Hartford. The World Hockey Association was but one of the major factors that eroded the Bruins' chance at achieving true dynasty status during the 1970s. Lured by big contracts, longtime stars such as Ted Green, Derek Sanderson, and John "Pie" McKenzie defected to the new league. (Collection of the Sports Museum.)

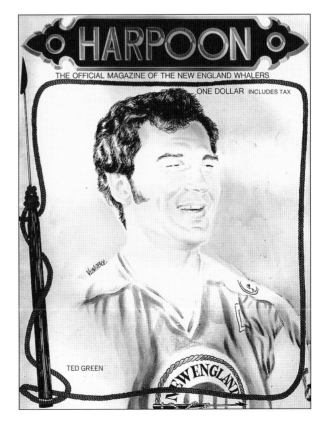

THE 1974 STANLEY CUP FINALS. Tom Bladon (left) and Richie Leduc battle in the 1974 Stanley Cup finals. By the early 1970s, the Flyers had developed into a powerhouse known as the "Broad Street Bullies." Stealing not a few pages from the Big Bad Bruins playbook, the Flyers used every form of intimidation to win. (Collection of the Sports Museum.)

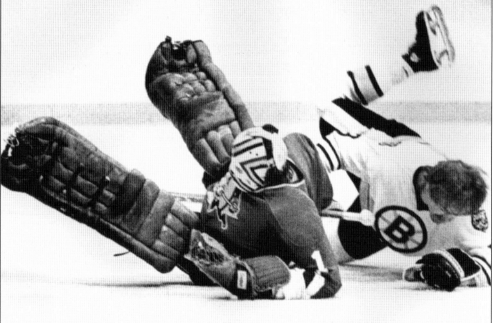

GREG SHEPPARD. Center Greg Sheppard, shown here in action against the Red Wings, was one of the players who made the transition from the Orr and Esposito Bruins to the "Lunchpail A.C." teams of the Don Cherry era. In six seasons with the Bruins, Sheppard scored 155 goals and captured both the Seventh Player Award and the Elizabeth Dufresne Award (given to the best Bruin in home games) during the 1975–1976 season. (Photograph by Pam Schuyler-Cowens.)

CAROL VADNAIS. Defenseman Carol Vadnais came to the Bruins with Don O'Donoghue in a trade for Reggie Leach, Rick Smith, and Bob Stewart in 1972. He played for the Bruins until going to the Rangers in the blockbuster Phil Esposito–Brad Park trade in 1975. (Photograph by Al Ruelle.)

STAN JONATHAN. Rookie Stan Jonathan walks to training camp at the Wallace Civic Center in Fitchburg in September 1975. In time, the forward endeared himself to Bruins fans with his relentless checking and accurate playmaking. He was also an accomplished fighter who won a celebrated victory over Montreal strongman Pierre Bouchard despite giving away nearly eight inches in height and 40 pounds to the Habs enforcer. (Photograph by Pam Schuyler-Cowens.)

DON CHERRY AND BLUE, 1978. Don Cherry was one of the most colorful coaches in Bruins history, which was certainly reflected in his attire. A sharp dresser with an equally sharp tongue, Cherry coached the Bruins for five years, taking them to the playoffs every year and the finals twice, in 1977 and 1978. After retiring from coaching, Cherry went on to a successful broadcasting career. (Photograph by Al Ruelle.)

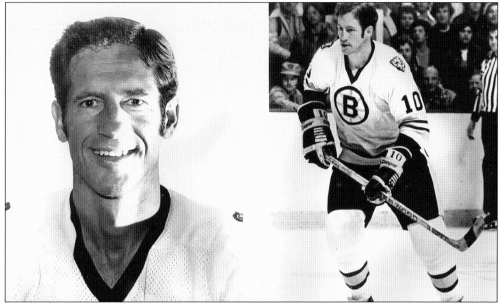

THE SECOND BIGGEST TRADE IN BRUINS HISTORY. Phil Esposito was the key player in the biggest trade in Bruins history when he came from the Blackhawks in 1967. On November 7, 1975, he was involved once again when the Bruins and Rangers made one of the biggest trades in NHL history. Esposito and Carol Vadnais went to New York in exchange for Brad Park, Jean Ratelle (shown above in both images), and journeyman defenseman Joe Zanussi. In six seasons with the Bruins, Ratelle scored 155 regular-season goals and helped lead the team to consecutive appearances in the Stanley Cup finals in 1977 and 1978. (Photograph by Al Ruelle.)

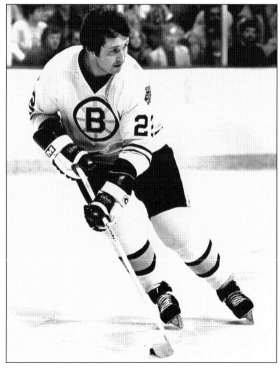

BRAD PARK. For much of his career, all-star defenseman Brad Park played in the lengthy shadow of Bobby Orr. For a brief period, the two were Bruin teammates before Orr's injuries and his ill-fated exit to the Blackhawks. Park soon became the Bruins' top defensive gun and finished his Bruins career as one of the top five defensemen in team history in the categories of points (fourth), goals (fifth), and assists (third). (Photograph by Al Ruelle.)

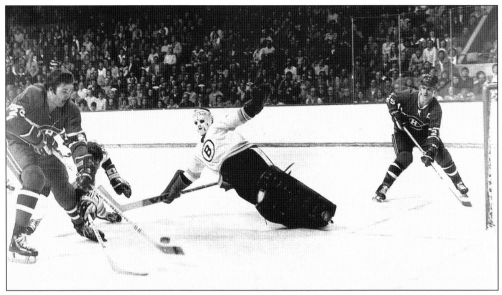

GILLES GILBERT. Gilles Gilbert was one of the most acrobatic goalies in NHL history. Acquired from Minnesota in 1973 to fill the hole left by the defection of Gerry Cheevers to the WHA, Gilbert helped lead the Bruins to a near upset in the 1979 Stanley Cup semifinals against the Canadiens. Gilbert is shown here against the Habs with Pete Mahovlich (left) attempting to feed winger Jacques Lemaire at the edge of the crease. Gilbert performed superbly in the series only to surrender a power-play goal to Guy LaFleur and an overtime winner to Yvon Lambert in the seventh game at the Montreal Forum. (Photograph by Al Ruelle.)

BOBBY SCHMAUTZ. The tough right winger came to Boston from Vancouver in a trade for Fred O'Donnell and Chris Oddleifson in 1974. A quintessential lunchpail Bruin, he added some punch to the Bruins lineup. An interesting note is that the trade with Vancouver was not without difficulty. Fred O'Donnell refused to report to the Canucks, prompting general manager Phil Maloney to run advertisements in the Boston papers saying, "Fred O'Donnell; Try Us . . . You might like us!" He did not succumb to Vancouver's blandishments, jumping to the Whalers of the WHA instead. (Photograph by Pam Schuyler-Cowens.)

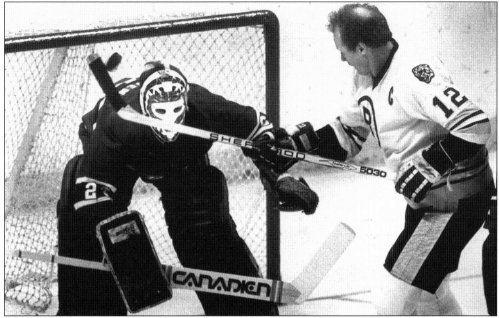

THE 1978 PLAYOFFS. Wayne Cashman deflects the puck toward Canadiens goalie Ken Dryden in the sixth game of the Stanley Cup semifinals at Boston. The Bruins' 5-2 victory forced a seventh game two nights later at the Montreal Forum. (Photograph by Pam Schuyler-Cowens.)

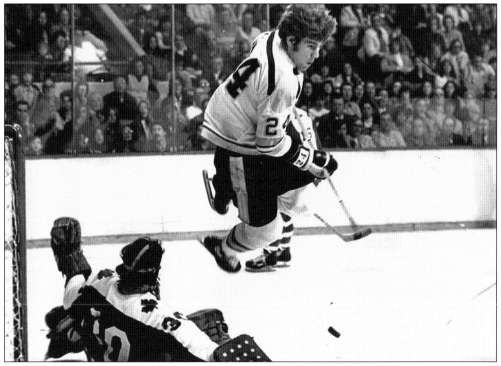

TERRY O'REILLY. Terry O'Reilly, with typical reckless abandon, leaps over Maple Leaf goalie Mike Palmateer and just misses a goal. In 14 seasons with the Bruins, O'Reilly scored 204 regular-season goals while amassing a team-record 2,095 penalty minutes. (Photograph by Al Ruelle.)

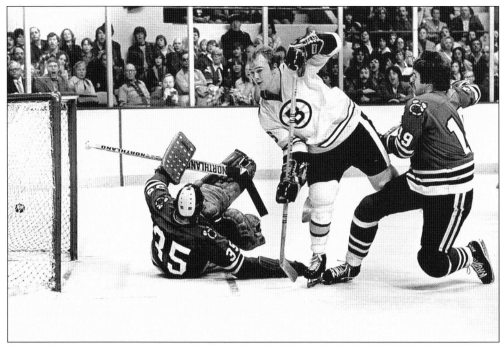

RICK MIDDLETON. Rick "Nifty" Middleton scores one of his team-leading 38 goals against Tony Esposito of the Blackhawks during the 1978–1979 season. Middleton arrived in Boston from the Rangers in a May 1976 trade for Ken Hodge and soon emerged as one of the most skilled right wings in the NHL. In 12 seasons with the Bruins, "Nifty" scored 402 regular-season goals and 496 assists. His final Bruins games were played in the 1988 Stanley Cup finals in which the team lost to the Edmonton Oilers. (Photograph by Pam Schuyler-Cowens.)

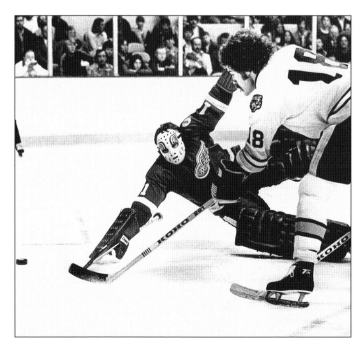

JOHN WENSINK. In just three seasons with the Bruins, left winger John Wensink (shown scoring against Red Wing goalie Jim Rutherford) made his name as one of coach Don Cherry's toughest customers. With his trademark mop of hair, Fu Manchu moustache, and perennial scowl, he was best known as a fighter who entertained fans with epic battles against the likes of Bob "Battleship" Kelly. Wensink was underrated as a scorer, averaging just under 20 goals per season. (Photograph by Pam Schuyler-Cowens.)

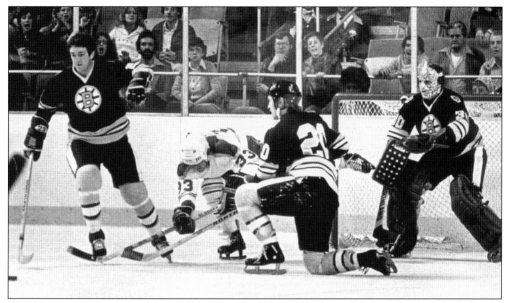

THE NEW AND THE OLD. "Orr era" veterans Rick Smith (left) and Gerry Cheevers (right) were still playing into the lunchpail era alongside players such as Al Secord (center). Both Smith and Cheevers had actually left the team and returned—Smith to California in a trade (1972), Cheevers to the WHA (1973). (Photograph by Pam Schuyler-Cowens.)

GERRY CHEEVERS. In his final season with the Bruins, Gerry Cheevers shared goaltending duties with Gilles Gilbert and won 11 of his 24 starts with a 2.81 goals against average. In 13 Bruin seasons, interrupted by a four-season stint in the World Hockey Association, Cheevers was recognized as one of the top money goalies of all time while helping lead the Bruins to Stanley Cups in 1970 and 1972. In 1985, he was elected to the Hockey Hall of Fame. (Photograph by Pam Schuyler-Cowens.)

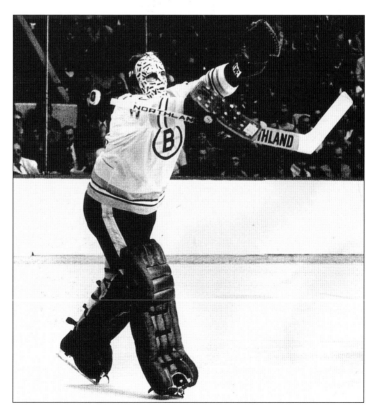

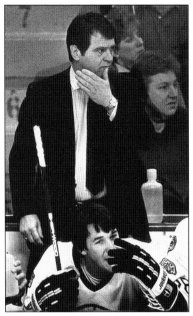

HARRY SINDEN RETURNS TO THE BENCH. After firing head coach Fred Creighton with seven games remaining in the 1979–1980 season, Bruins general manager Harry Sinden (shown here with Mike Milbury) returned for his second stint as the Bruins' coach. He led the team to a 6-1 record for the balance of the season before losing to the Islanders in a hard-fought five-game Stanley Cup semifinal that featured overtime losses in the first two games in Long Island. Sinden returned to the executive suite by the start of the following season after hiring Gerry Cheevers as his successor. (Photograph by Al Ruelle.)

THE END OF AN ERA. The Bruins' magical era of the 1970s ended early, as did the unforgettable career of Bobby Orr. The Bruins retired the superstar's No. 4 in an emotional ceremony prior to a Bruins exhibition game against the Soviet Wings on January 10, 1979. Orr is shown greeting Bruins Al Secord (left), Terry O'Reilly (center), and Peter McNab. At the time he played his final Bruins game in 1975, he was only 27 years old yet had won two Conn Smythe Trophies as playoff MVP, three Hart Trophies as the NHL MVP, two Art Ross Trophies as the league's leading scorer, and eight Norris Awards as the NHL's best defensemen. Milt Schmidt put it best when he remarked, "If there is a better hockey player than Bobby Orr I hope the good Lord keeps me alive long enough to see him." (Collection of the Sports Museum.)

Three

1980–1989

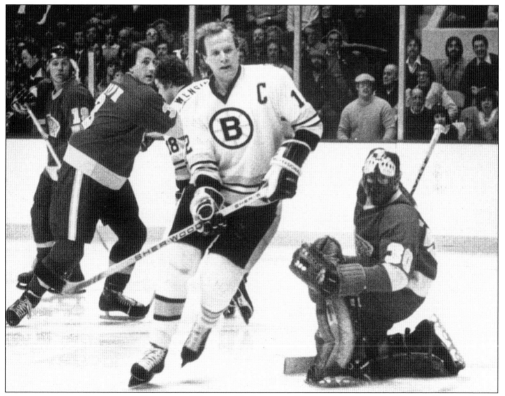

LEADING BY EXAMPLE. Captain Wayne Cashman charges in against future Bruin Rogie Vachon. While tough guy John Wensink ties up a Kings defenseman, another future Bruin player and coach, Butch Goring (No. 19), looks on. Cashman wore the C from 1977 to 1983. (Collection of the Sports Museum.)

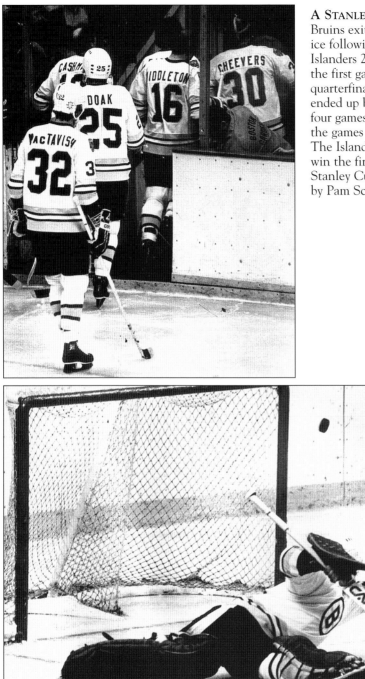

A Stanley Cup Defeat. The Bruins exit the Boston Garden ice following the New York Islanders 2-1 overtime victory in the first game of their Stanley Cup quarterfinal series. The Islanders ended up beating the Bruins four games to one, with three of the games decided by one goal. The Islanders then went on to win the first of four successive Stanley Cups. (Photograph by Pam Schuyler-Cowens.)

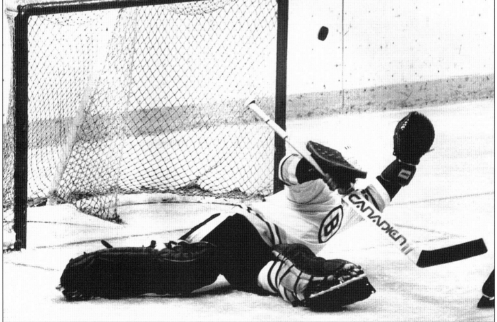

Marco Baron. Goalie Marco Baron tips a St. Louis Blues shot wide in a 7-4 loss at Boston Garden. Baron was one of the many journeyman goaltenders to briefly wear the black and gold. He played 64 games for the Bruins over parts of four seasons, from 1979 to 1983, and posted a career 3.40 goals against average. (Photograph by Pam Schuyler-Cowens.)

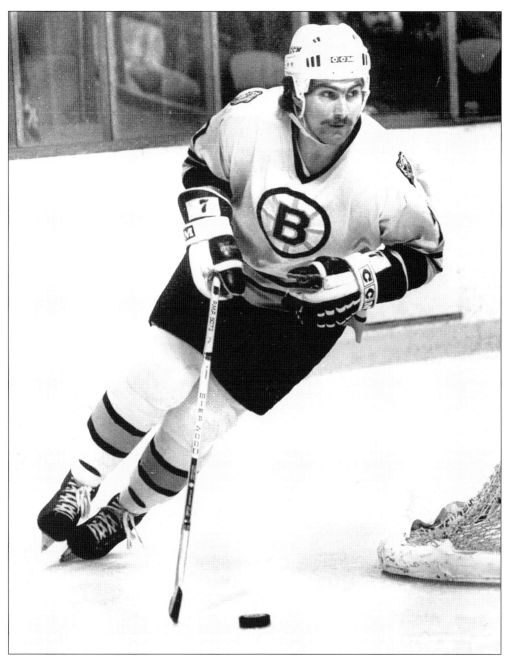

RAY BOURQUE. Ray Bourque came up to the Bruins in 1979 as a highly touted rookie. Although seemingly injury prone at first, he went on to be a rock-solid defenseman and team leader. (Photograph by Al Ruelle.)

BRAD PARK AND HIS SON ROBBIE. Bruin Hall of Fame defenseman Brad Park wheels his son Robbie, age six, on the Boston Garden ice for the Bruins' annual Christmas party. (Photograph by Al Ruelle.)

GARY DOAK. Bruin defenseman Gary Doak conducts a hockey clinic prior to the 1981 season. Doak was the quintessential "stay at home" defenseman who was willing to throw himself in front of anything to protect his goal. A product of the Red Wings system, he came to the Bruins in 1966. Doak's hard-hitting, solid defensive play contributed to the Stanley Cup win in 1970. He was claimed by Vancouver in the 1970 expansion draft and played for the Canucks, Rangers, and Red Wings before returning to Boston in 1973. He finished his career with the Bruins in 1981. (Photograph by Pam Schuyler-Cowens.)

JIM CRAIG. Bruin goalie and 1980 U.S. Olympic team hero Jim Craig, a North Easton native, played in every game in the United States' run to the gold medal in 1980. After the Olympics, he signed with the Atlanta Flames but played only four games. He fulfilled a dream of playing for the hometown team when he came to the Bruins in 1980. (Collection of the Sports Museum.)

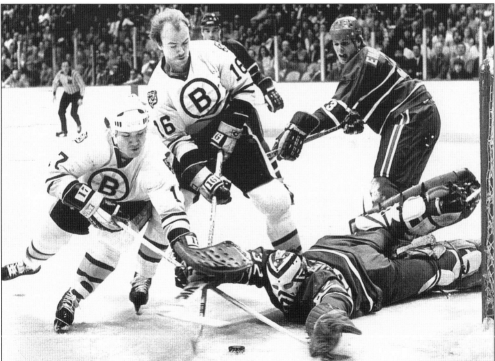

STAN JONATHAN AND RICK MIDDLETON. Stan Jonathan (left) and Rick Middleton crash the Montreal crease as goalie Denis Herron sprawls to make a save. Canadiens defenseman Brian Engblom can only watch. Between Jonathan's willingness to drop the gloves and Middleton's playmaking, the two helped make the Bruins an entertaining and effective team. (Photograph by Mike Andersen.)

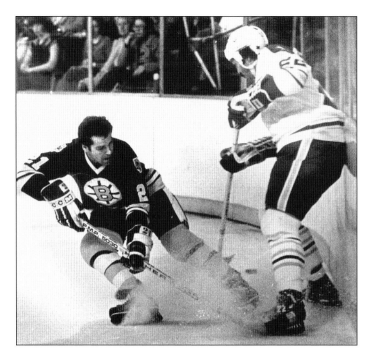

DON MARCOTTE. Don Marcotte digs the puck from the skates of another player. The quiet, steady Marcotte played his entire NHL career in Boston, coming up with the Bruins in 1969–1970 (not counting brief stints in 1965–1966 and 1968–1969). He played on both Stanley Cup teams (1970 and 1972) and retired in 1982. (Photograph by Pam Schuyler-Cowens.)

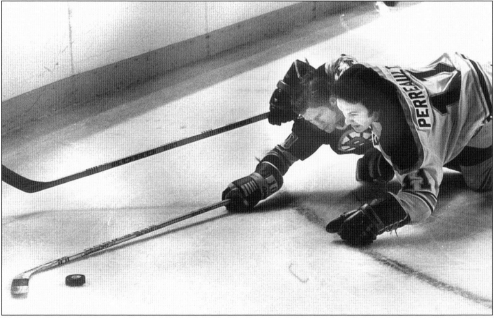

JEAN RATELLE AND GILBERT PERREAULT. Bruins all-star center Jean Ratelle and fellow Hall of Famer Gilbert Perreault of the Buffalo Sabres scramble for the puck at the old Buffalo Auditorium. Jean Ratelle came to the Bruins in the Esposito and Vadnais for Park and Ratelle trade of November 1975. Known as a gentleman, the two-time Lady Byng winner played with finesse and style over his 21-year career. (Photograph by Pam Schuyler-Cowens.)

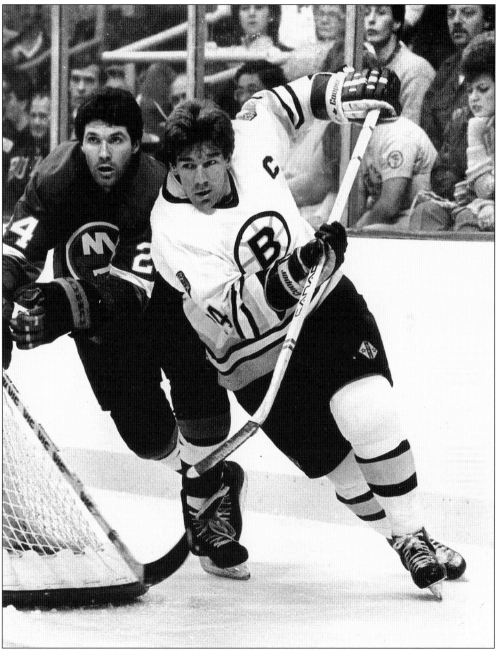

TERRY O'REILLY. No Bruin in history has worked as hard to improve his skills as Terry O'Reilly did. His hard-nosed style of play earned him the nickname the "Tasmanian Devil," or simply "Taz." (Photograph by Al Ruelle.)

PETE PEETERS. Pete Peeters made a strong impression in his first season with the Bruins, as the former Flyer won the Vezina Trophy with a 2.36 goals against average and 8 shutouts. He also recorded a 31-game unbeaten streak, just one game shy of the NHL record set by former Bruin Gerry Cheevers. (Photograph by Ren Norton.)

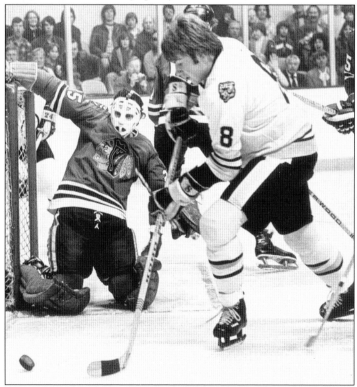

PETER MCNAB. Peter McNab drives in on Blackhawks goalie Tony Esposito. The six-foot-three-inch McNab came to the Bruins from Buffalo as compensation for Andre Savard in 1976. He was an effective scorer in his eight seasons in Boston, tallying 263 goals. (Photograph by Pam Schuyler-Cowens.)

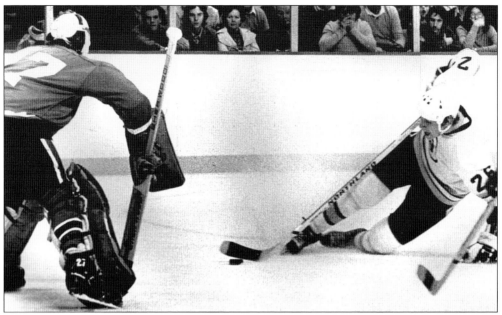

MIKE MILBURY. Mike Milbury skates toward Gilles Meloche. Walpole's Mike Milbury came up to the Bruins after stints with the Rochester Americans and the Boston Braves (in the last year of the team's existence). The scrappy Colgate graduate became an anchor of the Bruins defense, playing his whole career in black and gold. (Photograph by Pam Schuyler-Cowens.)

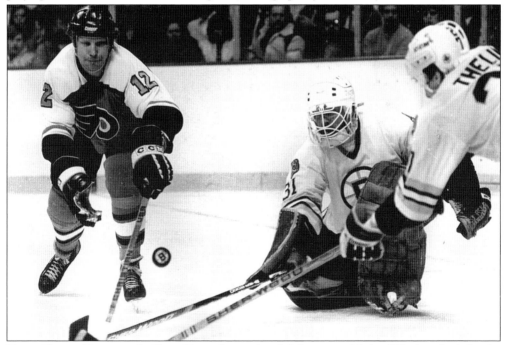

DOUG KEANS. Bruins goalie Doug Keans (center) and defenseman Michael Thelvin (right) poke check the puck from Flyers forward Tim Kerr. A journeyman goalie, Keans played 56 NHL games over four seasons in the Kings organization before coming to Boston in 1983. He played five seasons for the Bruins before finishing his career in the minors. (Photograph by Al Ruelle.)

STEVE KASPER. Center Steve Kasper charges out of the Bruins zone past Canadiens center Keith Acton. The immensely popular Kasper won both the Seventh Player Award and the Gallery Gods Award in his rookie season (1980–1981). His shadowing and checking of such offensive threats as Wayne Gretzky earned him a Selke Award as best defensive forward in 1981–1982. So liked and respected was he that when he was traded to Los Angeles in 1989, his teammates expressed their displeasure by putting his No. 11 on their practice jerseys with hockey tape. (Photograph by Al Ruelle.)

KEITH CROWDER. A member of the 1979 Memorial Cup champion Peterborough Petes team, Keith Crowder began his professional career with Birmingham of the WHA. (Collection of the Sports Museum.)

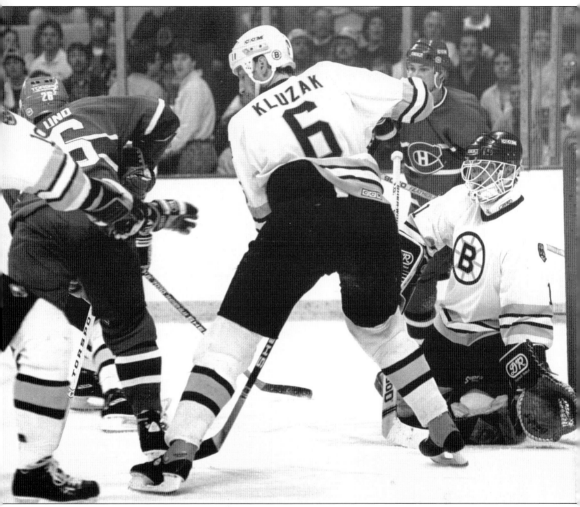

GORD KLUZAK. Some were surprised when the Bruins selected Gord Kluzak as the No. 1 pick in 1982. The six-foot-four-inch defenseman was Canada's junior male athlete that same year as well as a member of the World Junior Hockey Championship winning Team Canada squad. He more than lived up to the team's expectations until knee injuries cut his career short. The articulate Kluzak went on to become a broadcaster. (Photograph by Al Ruelle.)

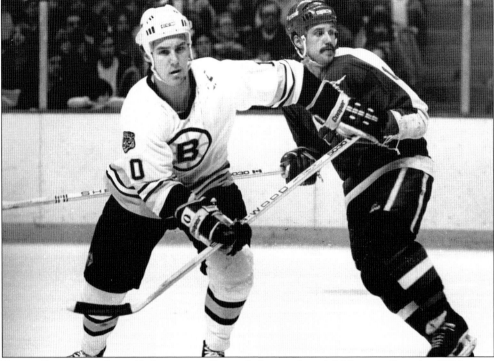

BARRY PEDERSON. Barry Pederson was Boston's first pick and 18th overall in the 1980 entry draft. He played for the Bruins until 1986, when he was involved in one of the many lopsided trades that pepper Bruins history. On June 6, 1986, he was traded to Vancouver for Cam Neely and Vancouver's first-round pick in the 1987 entry draft, which turned out to be Glen Wesley. (Courtesy of the Boston Bruins.)

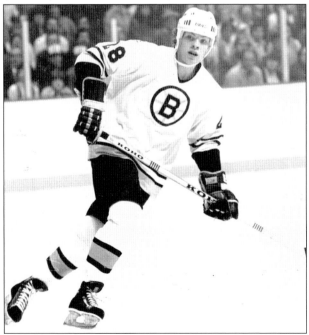

TOM FERGUS. The boyish Fergus was born in Chicago but grew up in Montreal. He played with Team USA in the 1985 World Championships in Prague. Traded to Toronto for Bill Derlago after four seasons, he had a long career with the Leafs before finishing his NHL playing days in Vancouver in 1993. (Courtesy of the Boston Bruins.)

CHARLIE SIMMER. Drafted by California, Charlie Simmer played most of his career in Los Angeles as a member of the "Triple Crown Line" with Marcel Dionne and Dave Taylor before being traded to the Bruins. The mustachioed left winger played three seasons in Boston before finishing his NHL career in Pittsburgh. (Courtesy of the Boston Bruins.)

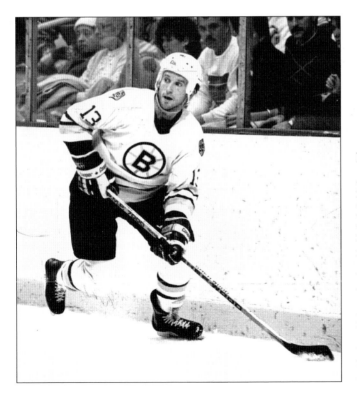

KEN LINESMAN. In June 1984, the Bruins traded Mike Krushelnyski to get Ken Linesman. The crafty veteran, nicknamed "the Rat," came up through the Philadelphia organization before joining Edmonton in time to net a Stanley Cup winning goal in Edmonton's 1984 win over the Islanders. He played six seasons in a Bruins uniform before being traded back to Philadelphia for Dave Poulin. (Courtesy of the Boston Bruins.)

CLEON DASKALAKIS. A standout goalie at Boston University, Cleon Daskalakis had a brief career between the pipes in Boston (12 games over three seasons). He was an Eastern College Athletic Conference (ECAC) Second Team All-Star in 1983 and a First Team All-Star in 1884, as well as an NCAA First All American in 1984. (Courtesy of the Boston Bruins.)

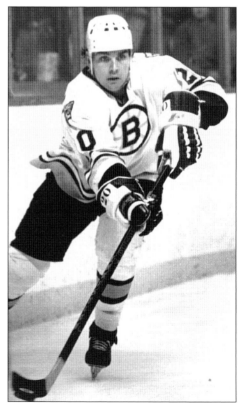

MIKE O'CONNELL. Defenseman Mike O'Connell was raised in Cohasset and attended Archbishop Williams High School in Braintree for two years before going to Canada to play junior hockey in the Ontario Hockey League. He turned professional with the Chicago Blackhawks and after five-plus seasons in Chicago was traded to the Bruins on December 18, 1980, for Al Secord. In six seasons with the Bruins, O'Connell enjoyed great success while playing in the 1984 All-Star Game and capturing the WSBK TV Seventh Player Award for the 1983–1984 season. O'Connell was named vice president and general manager of the Bruins on November 1, 2000. (Courtesy of the Boston Bruins.)

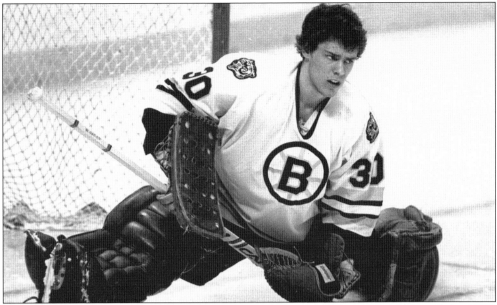

MIKE MOFFAT. Brought in to help back up star goalie Pete Peeters, Mike Moffat made his NHL debut in April 1982. Although he saw limited action, he was the surprise hero of the playoffs, backstopping the Bruins to the seventh game of the division finals. He never recaptured that spark, however, and only played parts of three seasons (1981–1982, 1982–1983, and 1983–1984) for the Bruins before finishing his career in the minors. (Courtesy of the Boston Bruins.)

RANDY BURRIDGE. Although small in stature, Randy "Stump" Burridge was an effective left winger for the Bruins. A big part of the Bruins' success in getting to the Stanley Cup finals in 1988 and 1990, "Stump" was traded to the Capitals in 1991 for Steve Leach. (Courtesy of the Boston Bruins.)

AN OVERTIME VICTORY. The Bruins celebrate their overtime series-clinching 3-2 victory over the Buffalo Sabres on April 24, 1983. Brad Park's clincher was one of the greatest Bruin

moments since the days of the Orr and Esposito teams. (Photograph by Dick Raphael.)

RAY BOURQUE AND GORDIE HOWE. Ray Bourque receives an award from "Mr. Hockey," Gordie Howe, in 1983. The name Gordie Howe was synonymous with durability, as he played 1,767 regular season and 157 playoff games over 25 NHL seasons. After two years of retirement, he returned to professional hockey with the WHA, playing alongside his sons Mark and Marty with the Houston Aeros. He finished his career with the Hartford Whalers in 1979–1980, the year they merged into the NHL. (Photograph by Al Ruelle.)

THE COVER OF OPEN NET. "Professional Amateur" George Plimpton wrote this book about his 1977 training camp stint and exhibition game action against the Philadelphia Flyers. The players may have exaggerated their exploits, but the book captured the spirit of the team on the road, in the locker room, and on and off the ice. (Courtesy of Richard A. Johnson.)

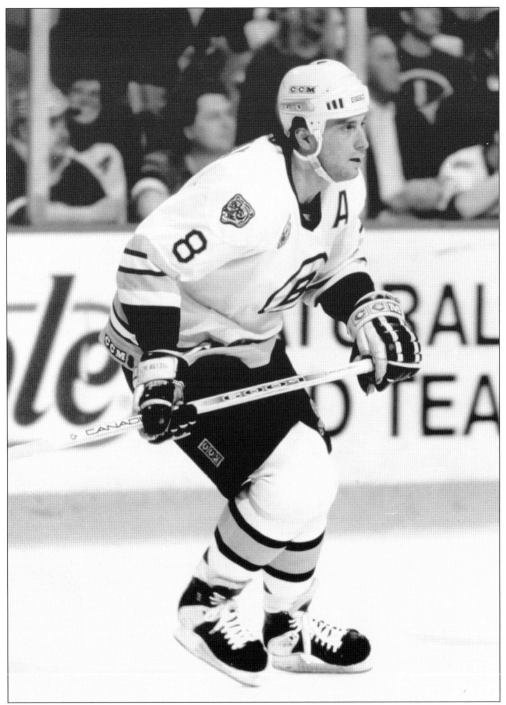

CAM NEELY. Cam Neely played 10 seasons with the Bruins before being forced to retire due to injuries. A three-time 50-goal scorer with a career-high 55 goals in the 1988–1990 season, he won the Bill Masterton Trophy 1994, the Seventh Player Award in 1987, and the Dufresne Award in 1988, 1991, and 1994. Neely was a four-time second team all-star, in 1988, 1990, 1991, and 1994. (Courtesy of the Boston Bruins.)

BILL RANFORD. The intense goaltender began his NHL career with the Bruins but was traded (along with Geoff Courtnall) to Edmonton for Andy Moog. Playing on two Stanley Cup winners, he was traded back to Boston in 1996. The following season, he was traded again, this time to Washington. (Courtesy of the Boston Bruins.)

BUTCH GORING. Butch Goring played 16 seasons in the NHL, mostly for the Kings and Islanders (with whom he won four Stanley Cups). He finished his career in Boston, and in February 1985, he was named coach. He would skipper the club until the November 1986, when he was replaced by Terry O'Reilly. (Courtesy of the Boston Bruins.)

TERRY O'REILLY. Terry O'Reilly took over as coach in November 1986. He brought the same passion and leadership that he had on the ice to the bench. One notable incident of his career was the "replacement referee" game. Jim Schoenfeld, in many ways a carbon copy of O'Reilly in his playing days, was coaching New Jersey in the conference finals against Boston. Objecting to a call by referee Don Kohharski, he taunted the official. The referees wanted Schoenfeld's head, and when they failed to get it, they went on strike the next game. The NHL refused to cancel the game and fielded a motley collection of amateur officials to call the game. When the Bruins went on to the finals against Edmonton, there was another odd incident when, at 16:37 of game four, a power failure at the old Garden caused the game to be suspended. The teams returned to Edmonton, where the Bruins lost to the Oilers 6-3. In May 1989, O'Reilly was replaced by Mike Milbury, who took the team to the finals again in 1990. (Photograph by Al Ruelle.)

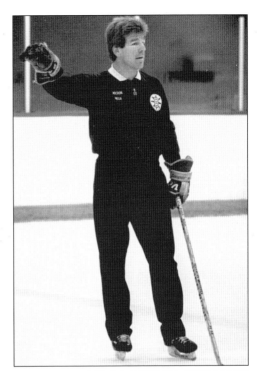

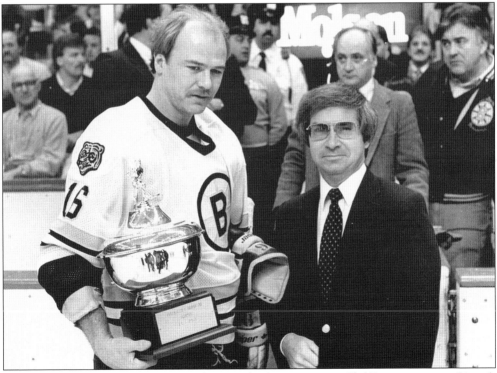

RICK MIDDLETON. In 1982, Middleton became the first Bruin since Phil Esposito to score 50 goals or more. In that same season, the winger, called "Nifty" by his teammates, was awarded the Lady Byng Memorial Trophy as the NHL's most gentlemanly player. (Courtesy of the Boston Bruins.)

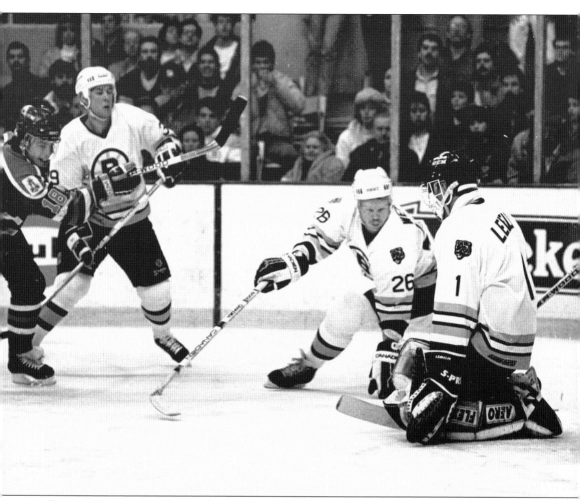

REGGIE LEMELIN. Reggie Lemelin enjoyed an Indian summer to his long career when he joined the Bruins in 1987. Shown here with teammates Greg Johnston (No. 39) and Glen Wesley (No. 26), he spent most of his career in the Flames organization, going back to when the team was in Atlanta. After nine seasons with the Flames, he signed as a free agent with Boston, teaming up with Andy Moog to face Edmonton in the 1988 and 1990 Stanley Cup finals.

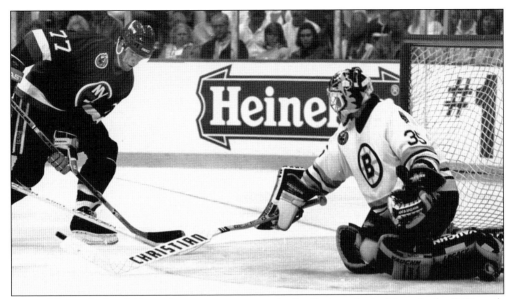

ANDY MOOG. In his 261 regular-season games with the Bruins, Andy Moog had a 3.07 goals against average and helped lead the Bruins to two Stanley Cup final appearances, in 1988 and 1990. His 2.99 goals per game playoff average is one of the best in team history. In the 1989–1990 season, Moog, along with Reggie Lemelin, helped the Bruins win the Jennings Trophy, given annually to the goaltending team with the best combined goals against average in the league. (Photograph by Al Ruelle.)

GLEN WESLEY. Glen Wesley came to the Bruins as Vancouver's draft pick in the 1987 entry draft, acquired in the Cam Neely and Barry Pederson trade. A solid performer, Wesley may be best remembered for shooting the puck over an open net in overtime in the opening-game loss in the 1990 Stanley Cup finals against Edmonton at the Boston Garden. (Photograph by Al Ruelle.)

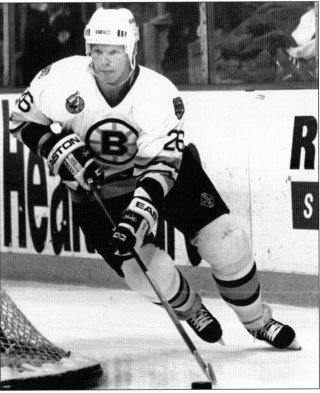

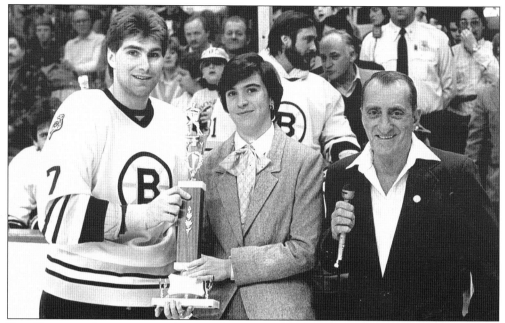

RAY BOURQUE RECEIVES AN AWARD. Ray Bourque receives the Dufresne Award from an unidentified woman and Gallery Gods head Roger Naples. The Gallery Gods had a long and proud tradition at Boston Garden, occupying the nether regions of the old building and cheering on generations of Bruins. Their annual award reflected those characteristics that, in their eyes, made a Bruin: hard hitting, hard skating, and lots of heart. Although their choice was not always a star like Bourque, those descriptions defined Ray's style of play. (Photograph by Al Ruelle.)

GEOFF COURTNALL. Geoff Courtnall, the brother of Russ Courtnall, began his career with the Bruins in 1983. He was involved in one of the biggest trades of the 1980s when he, Bill Ranford, and a draft pick were sent to Edmonton in exchange for Andy Moog in March 1988. The Bruins faced the Oilers in the finals that year, but Moog was not able to beat his old club. The Bruins and the Oilers faced off in he finals again in 1990, with the same results. (Collection of the Sports Museum.)

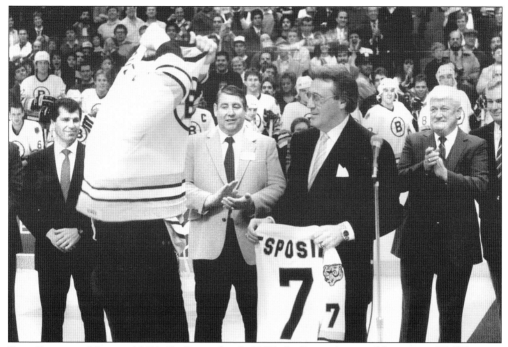

PHIL ESPOSITO NIGHT, 1987. On December 3, 1987, the Bruins honored former star Phil Esposito by hoisting his No. 7 to the rafters. While it was planned that current star Ray Bourque, who had worn that number since his arrival in 1979, would continue to wear it, in a surprise gesture he removed his jersey, revealing the now familiar No. 77. (Photograph by Al Ruelle.)

PHIL ESPOSITO AND RAY BOURQUE. Phil Esposito acknowledges Bourque's gesture. The number change by Bourque was completely unexpected and was a closely guarded secret until he pulled off the No. 7 sweater and handed it to Esposito. (Photograph by Al Ruelle.)

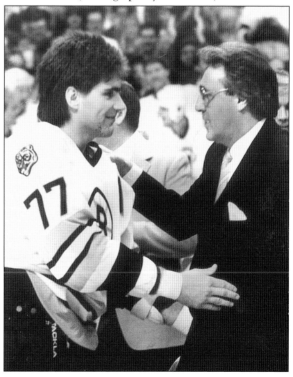

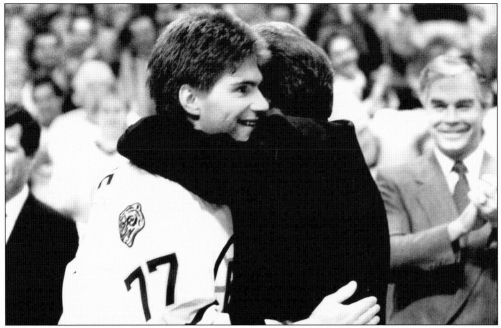

ESPOSITO AND BOURQUE. Bourque and Esposito embrace as Derek Sanderson looks on. Esposito was quite touched by the sincerity and spontaneity of Bourque's offering. The move was typical of the ever classy Bourque, who went on to see his new number hoisted to the rafters alongside Esposito's No. 7. (Photograph by Al Ruelle.)

CRAIG JANNEY. Connecticut's Craig Janney played for Boston College and the U.S. national and Olympic teams before coming to the Bruins at the end of the 1988 season. He played for the Bruins until 1992, when he was traded (with Stephane Quintal) to St. Louis for Adam Oates. (Photograph by Al Ruelle.)

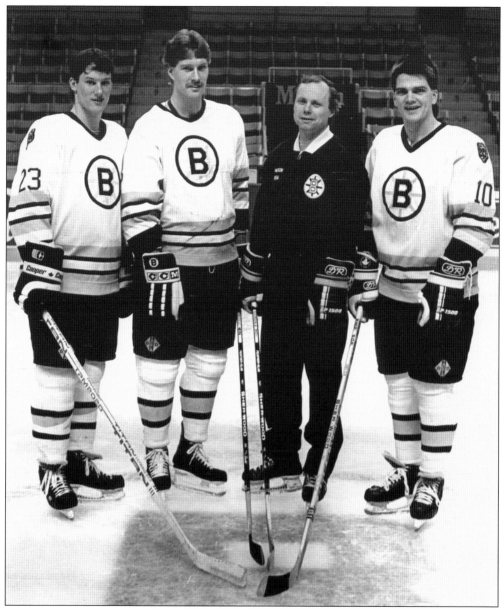

FROM EAGLES TO BRUINS. Boston College has produced many great hockey players. For a time in the late 1980s, the Bruins' roster featured, from left to right, the following Eagles: Craig Janney, Bob Sweeney, assistant coach John Cuniff, and Billy O'Dwyer. (Photograph by Al Ruelle.)

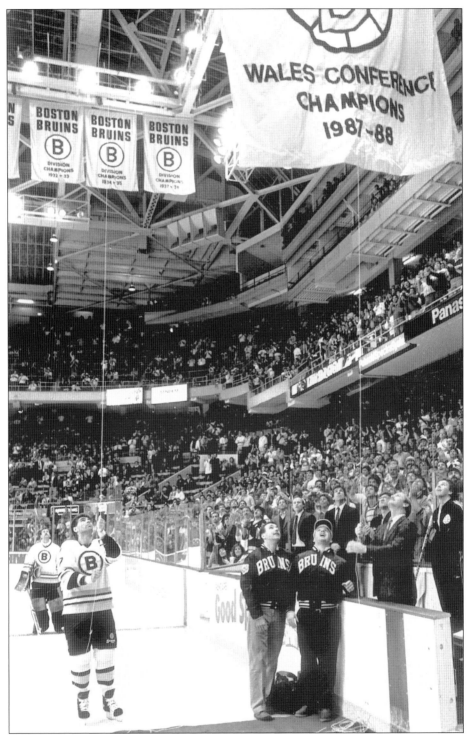

Ray Bourque Raises the 1987–1988 Wales Conference Banner. Ray Bourque raises the 1987–1988 Wales Conference banner to the Boston Garden rafters. After a long drought, the Bruins would finally return to the Stanley Cup finals. (Photograph by Al Ruelle.)

BOBBY JOYCE. Bobby Joyce came to the Bruins in time to play in the 1988 Stanley Cup finals but was traded to Washington (for Dave Christian) before the 1990 rematch. A standout at the University of North Dakota, he left after three years to join the Canadian Olympic team, playing in the 1988 Calgary games. He joined the Bruins after the conclusion of the games, playing his first NHL game in March of that year. (Courtesy of the Boston Bruins.)

ANDY BRICKLEY. The Melrose native was claimed by Boston from New Jersey in the 1988 waiver draft. Andy Brickley had an outstanding college career with the University of New Hampshire Wildcats before being drafted by Philadelphia. He played for the Flyers and Penguins before going to New Jersey. He spent four seasons in Boston and, after his retirement, became a Bruins television broadcaster. (Courtesy of the Boston Bruins.)

CAM NEELY. The hard-hitting, high-scoring Cam Neely would no doubt be in the Hall of Fame had his career not been cut short by injuries. He continues to be active in charitable endeavors, most notably the Neely House, for families of cancer patients, and Denis Leary's Worcester firefighters charity game. (Courtesy of the Boston Bruins.)

Four

1990–1999

BOBBY CARPENTER. The "Can't Miss Kid" was drafted out of St. John's Preparatory School in Danvers in 1981. He was the first American to go directly from high school to the NHL. He played for the Capitals, Rangers, and Kings before coming to the Bruins in January 1989 for Steve Kasper. Going back to the Capitals in the 1992–1993 season, he finished his career in New Jersey, winning a Stanley Cup in 1995. (Courtesy of the Boston Bruins.)

ALLAN PEDERSON, BOB SWEENEY, RAY BOURQUE, AND GORD KLUZAK. From left to right, Pederson, Sweeney, Bourque, and Kluzak pose at the Boston Garden. (Photograph by Steve Babineau.)

COACH MIKE MILBURY. Defenseman Mike Milbury played his whole 12-year NHL career in a Bruins uniform. A native of Walpole, Milbury grew up following the teams of Bobby Orr, Phil Esposito, and Gerry Cheevers. He attended Colgate University before signing with the Bruins as a free agent in 1974. A tough player, he held the team record for penalty minutes (199 in 1976–1977) before it was bested by Terry O'Reilly. After his retirement in 1987, he moved behind the bench, coaching the team until 1991. (Courtesy of the Boston Bruins.)

DAVE POULIN. The stylish Poulin came to the Bruins from Philadelphia for Ken Linesman in 1990. The Notre Dame product played for Boston until 1993, picking up the NHL's King Clancy Trophy (1993) for leadership on and off the ice. (Courtesy of the Boston Bruins.)

COACH TERRY O'REILLY. O'Reilly was beloved for his off-ice exploits as well as his "blood and guts" style of play. In one memorable incident in Hartford, O'Reilly broke the window of a car blocking the team bus with a tire iron in order to move the car and expedite his team's late-night drive home to Boston. (Collection of Brian Codagnone.)

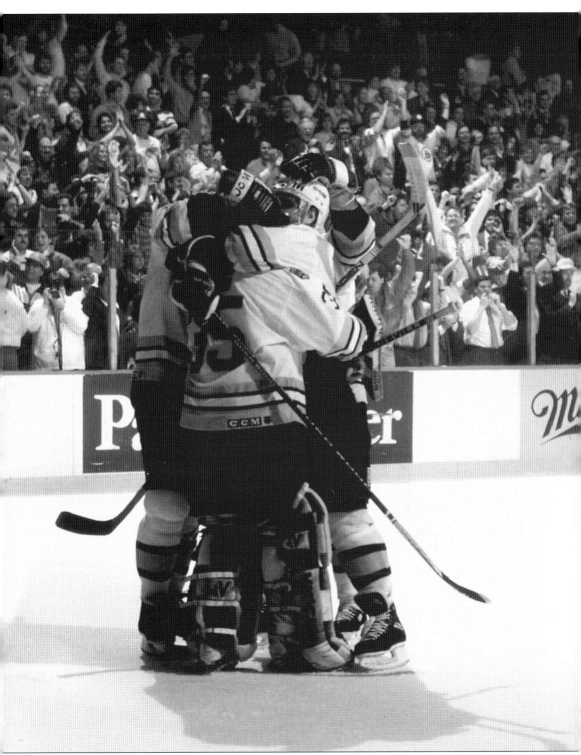

SWEEP! The Bruins celebrate their Stanley Cup semifinal sweep of the Washington Capitals following their 3-2 victory on May 9, 1990, at the Boston Garden. Their next opponents were

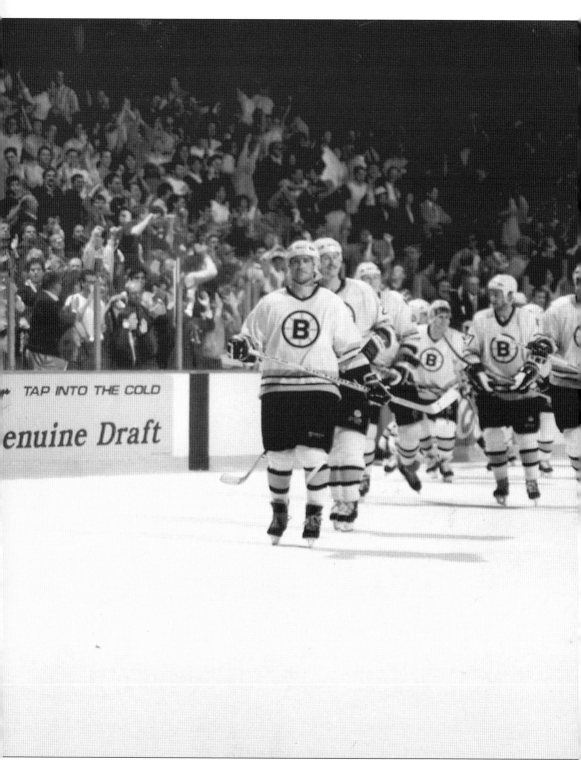

the Gretzky-less Edmonton Oilers. (Photograph by Dick Raphael.)

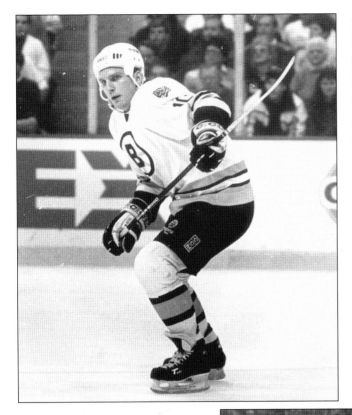

KEN HODGE JR. The son of Bruins star Ken Hodge, Ken Hodge Jr. was named to the NHL All-Rookie team and enjoyed a career in Boston from 1990 to 1992. Prior to turning professional, Hodge enjoyed a standout career at Boston College. (Photograph by Al Ruelle.)

BOB SWEENEY. Bob Sweeney grew up in Boxboro and played his high school hockey at Acton-Boxboro, where his teammates included Tom Barrasso. A standout at Boston College, he was drafted by the Bruins in 1982. In addition to the Bruins, he played for the Sabres, Islanders, and Flames. After his playing days, he returned to Boston to become involved in the Bruins alumni organization. (Courtesy of the Boston Bruins.)

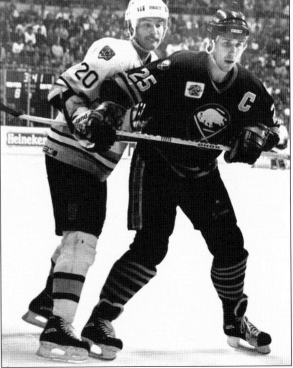

GARRY GALLEY. Signed as a free agent in 1988 to add stability to the blue line, Galley played more games that first season than any other defenseman. Originally drafted by the Kings, he was traded to Washington in his third season before coming to Boston. Respected by teammates, fans, and management alike, he wore the C for four games during the division semifinals against Hartford in Ray Bourque's absence. A career highlight was scoring the overtime goal to defeat Montreal in game two of the 1990 Adams Division finals, paving the way to the Stanley Cup playoffs against Edmonton. (Courtesy of the Boston Bruins.)

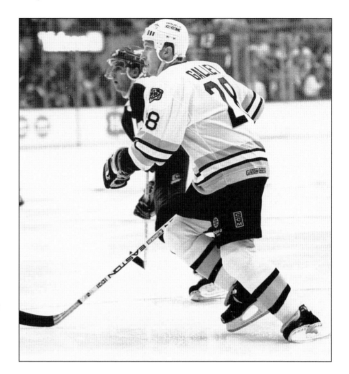

WES WALZ. Wes Walz was a small forward in the old Bruin mold of Gregg Shepperd and looked to be a future star. However, contract issues led to his trade to Philadelphia as part of the Garry Galley and Gord Murphy deal in 1992. (Courtesy of the Boston Bruins.)

CHRIS NILAN. "Knuckles" Nilan was born to be a Bruin, but played most of his career in the uniforms of the Canadiens and Rangers. The West Roxbury native and Catholic Memorial and Northeastern University product played nine seasons in Montreal (including a Stanley Cup win in 1986) before being traded to the Rangers in 1988. In 1990, he was traded to Boston, where he intimidated, taunted, needled, and fought opponents until 1992. (Courtesy of the Boston Bruins.)

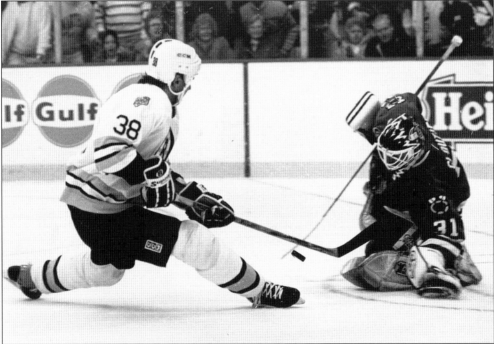

VLADIMIR RUZICKA. The supremely talented Czech never lived up to his potential. After his rookie season in Edmonton, he came to Boston, where he played three seasons. Showing flashes of brilliance and scoring the occasional highlight reel goal, he was inconsistent. He was released in 1993 and played one more NHL season, in Ottawa. (Courtesy of the Boston Bruins.)

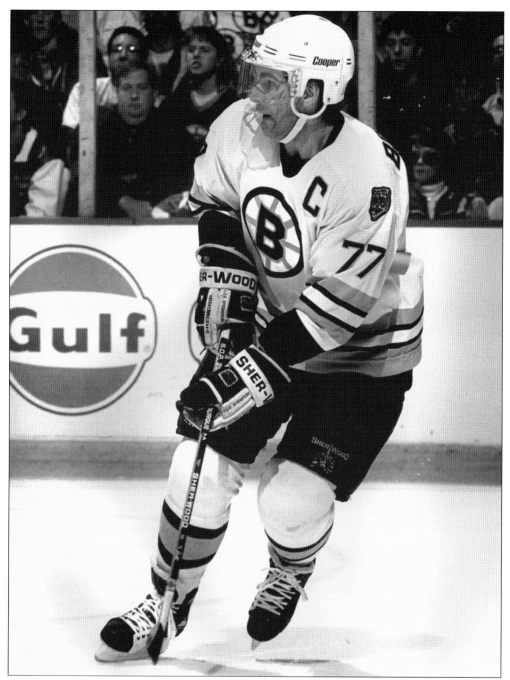

CAPTAIN RAY BOURQUE. Bruins captain Ray Bourque wore the C from 1988 until his departure in 2000, having shared the honor with Rick Middleton following Terry O'Reilly's retirement in 1985. The Bruins' first-round pick in 1979, he won the Calder Memorial Trophy in 1980; the Norris Trophy in 1987, 1988, 1990, 1991, and 1994; the King Clancy Trophy in 1992; and the Dufresne Award in 1985, 1986, 1987, 1990, 1994, and 1996. On February 1, 1997, he became the Bruins' all-time scoring leader with 1,340 career points. (Photograph by Al Ruelle.)

STEVE LEACH. The former University of New Hampshire Wildcat was chosen by Washington in the 1984 entry draft. Between stints in Washington and Binghamton, he played on the U.S. national and Olympic teams. He returned to his home town when the Bruins traded Randy Burridge to the Capitals. (Courtesy of the Boston Bruins.)

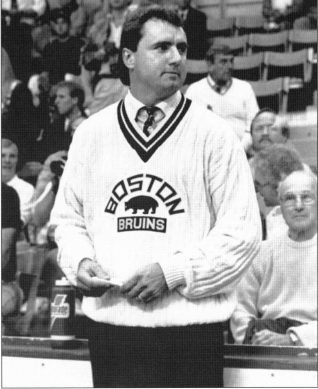

RICK BOWNESS. Rick Bowness coached the Bruins in the 1991–1992 season. Like many coaches, he was a journeyman player, enjoying a seven-year NHL career with Atlanta, Detroit, St. Louis, and Winnipeg before moving behind the bench. (Courtesy of the Boston Bruins.)

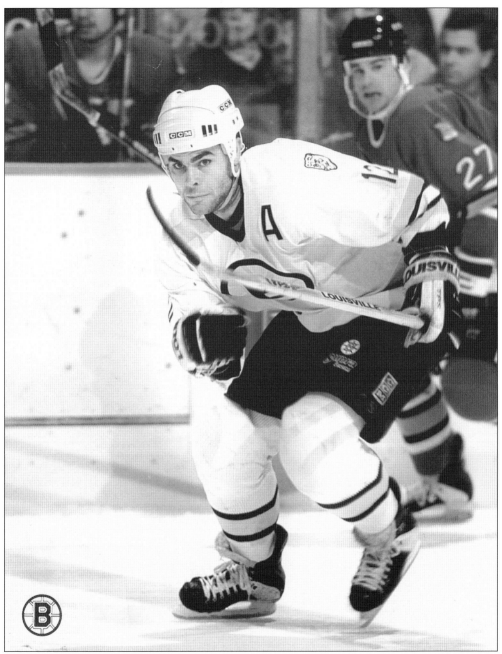

ADAM OATES. Adam Oates arrived from St. Louis in the trade for Craig Janney and became the Bruins' best forward in Cam Neely's absence. Oates enjoyed the best season of his career in the 1992–1993 season and continued as a solid performer before being traded to Washington in 1997. (Photograph by Steve Babineau.)

FRED CUSICK. In 1992, Fred Cusick celebrated his 40th season as a Bruins play-by-play announcer. The Brighton native and former Northeastern University hockey captain broadcast games on both radio and television spanning an era that saw the NHL grow from 6 teams to the 26 teams existing at the time of his retirement from the Bruins. (Collection of the Sports Museum.)

DMITRI KVARTALNOV. The first player from the former Soviet Union to play for the Bruins, Dmitri Kvartalnov played two seasons in the NHL, both with Boston. A veteran of Khimik Voskresensk of the Soviet Elite League, Kvartalnov played for the Soviet national team in the 1990 world tournament. (Courtesy of the Boston Bruins.)

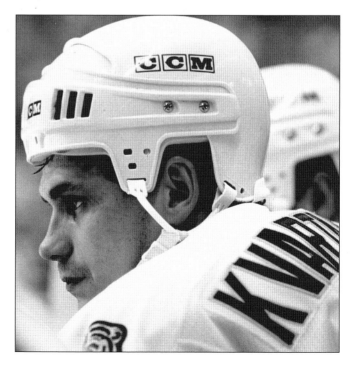

TED DONATO. Raised in Dedham and educated at Catholic Memorial and Harvard (where he won an NCAA championship and was named MVP in 1988–1989), Ted Donato played on the U.S. national and Olympic teams before coming to the Bruins. In his eighth season in Boston, he was traded to the Islanders. (Courtesy of the Boston Bruins.)

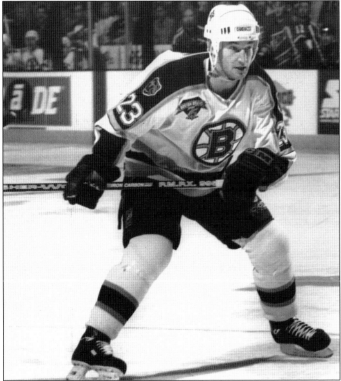

STEVE HEINZE. Local boy Steve Heinze played at Lawrence Academy in Groton before joining the U.S. junior national team in 1988 and 1989. He also played for Boston College, earning all-star honors. Prior to joining the Bruins, he enjoyed stints with the U.S. national and Olympic teams. (Courtesy of the Boston Bruins.)

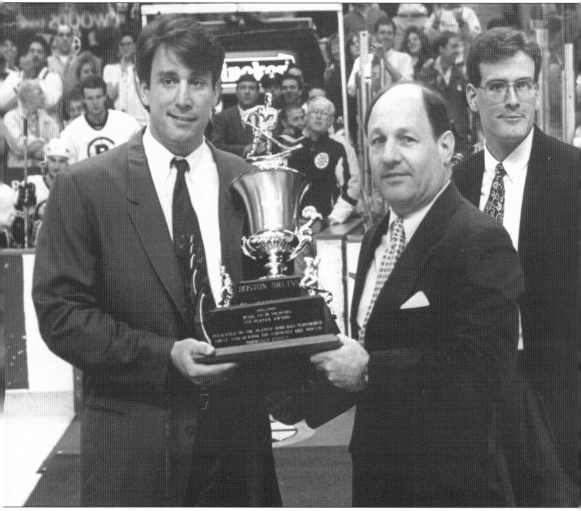

CAM NEELY. After suffering knee and thigh injuries, Cam Neely made an amazing comeback in the 1993–1994 season with 50 goals in 49 games. That season, he won the Masterton Trophy for perseverance and sportsmanship but, slowed by persistent injuries, was forced to retire in 1996. (Photograph by Al Ruelle.)

AL IAFRATE. Al Iafrate was a heavy-metal, Harley-riding rebel who possessed one of the hardest shots in NHL history. Coming to Boston from the Capitals, Iafrate played part of a season in Boston (1993–1994) before being traded to San Jose. (Photograph by Steve Babineau.)

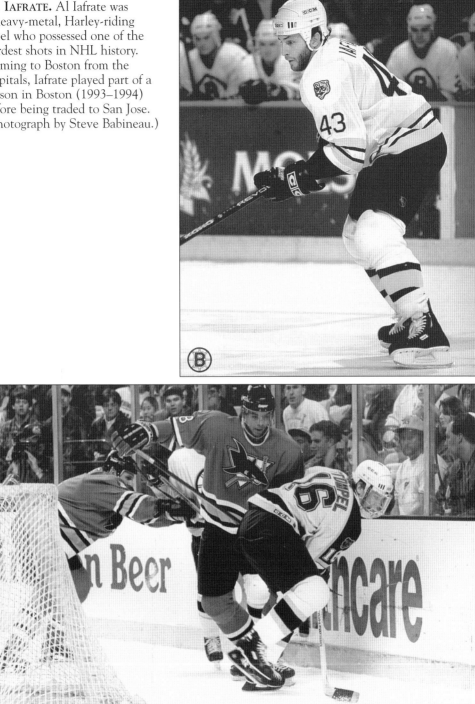

JOSEF STUMPEL. A native of Slovakia, Josef Stumpel was involved in two major Bruins trades. In the first, he was sent to Los Angeles with Sandy Moger for Byron Dafoe and Dimitri Khristich in 1997. In 2001, he came back to Boston with fellow Bruins alumni Glen Murray for Jason Allison and Mikko Eloranta. (Photograph by Al Ruelle.)

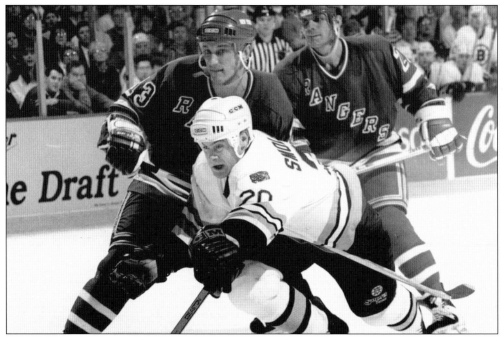

BRYAN SMOLINSKI. Bryan Smolinski came to Boston in 1993 after a successful college career at Michigan State University. After three seasons in a Bruins uniform, he was traded to Pittsburgh in the Kevin Stevens deal. (Courtesy of the Boston Bruins.)

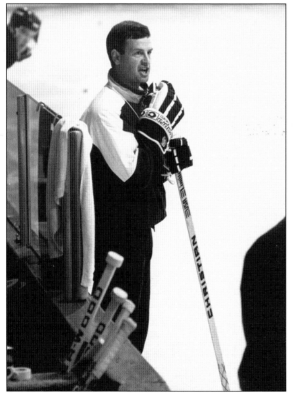

BRIAN SUTTER. A hard-nosed player and one of six brothers to play in the NHL, Brian Sutter was named the Bruins' coach in June 1992 and held the reins until May 1995. The high point of his tenure was a rousing seven-game conference quarterfinals against Montreal in 1994 in which the Bruins defeated the defending Stanley Cup champions. (Courtesy of the Boston Bruins.)

BLAINE LACHER. Blaine Lacher came to Boston after a sensational college career at Lake Superior State, where he played on the 1992 NCAA championship team. In his final season (1993–1994), he led the nation in goals against average (1.98) and save percentage (.918) and earned Central Collegiate Hockey Association (CCHA) top goaltender and all-tournament team honors. After an impressive rookie year that saw him go 6-1-0 in his first seven decisions, Lacher never lived up to his potential, leaving the scene after only two years in a Bruins uniform. (Photograph by Steve Babineau.)

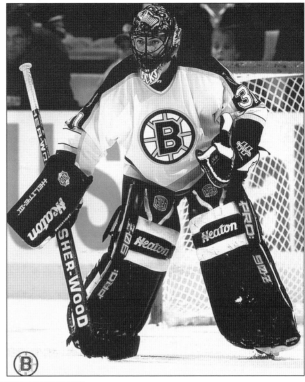

CRAIG BILLINGTON. The well-traveled goaltender came to Boston in 1995. He had played most of his career in the New Jersey system, moving between the big club and the minors. He spent the 1990–1991 season with the Canadian national team. (Courtesy of the Boston Bruins.)

A GOODBYE TO THE GARDEN. The Bruins bid farewell to their Boston Garden home after 67 memorable seasons with the playing of both the final playoff game, a 3-2 loss to the New Jersey Devils in May, and a September exhibition game against the Montreal Canadiens. Despite its obstructed views and endless stairways, the Garden was the most intimate of all Boston sporting

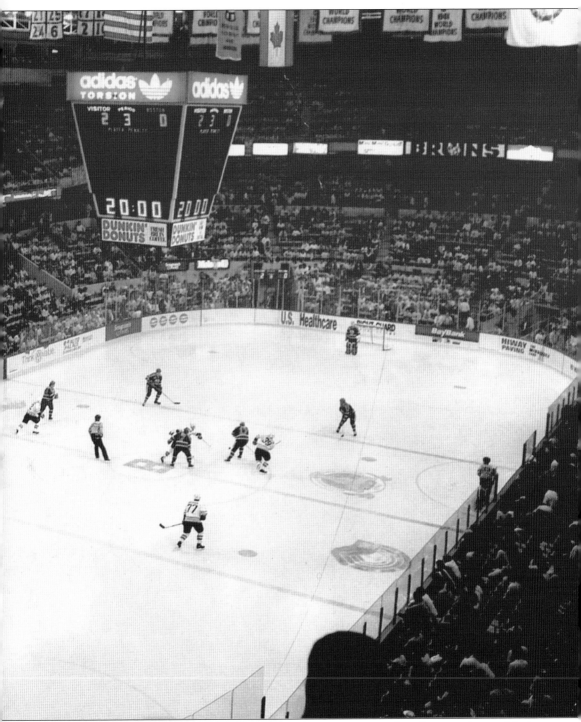

venues. For most of their seasons, the Bruins played to capacity crowds and captured two of their five Stanley Cups on home ice, in 1939 and 1970. The building was leveled in 1998 as part of the ongoing development of the North Station neighborhood. (Photograph by Tom Miller.)

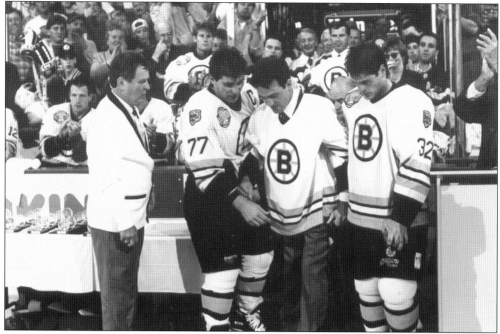

NORMAND LEVEILLE. Norman Leveille (center) stands with Ray Bourque and Don Sweeney at the final game at the Boston Garden in September 1995. Levielle's emotional return to the Boston Garden came 13 years after he suffered a near-fatal cerebral hemorrhage in a game in Vancouver on October 23, 1982. Levielle was the youngest player drafted to date by the Bruins and was considered a potential star forward at the time of his illness. (Photograph by Al Ruelle.)

SANDY MOGER. The British Columbia native played for four years at Lake Superior State before turning professional with the American Hockey League (AHL) Hamilton Bulldogs. He signed as a free agent with Boston in 1994. He played three seasons in Boston before being traded to Los Angeles. (Courtesy of the Boston Bruins.)

Sean McEachern. Born in Waltham, Sean McEachern played hockey at Boston University. After four years in Pittsburgh (and a brief stint in Los Angeles), he came to Boston in 1995. After one season with the Bruins, he went to Ottawa, where he played six seasons. (Courtesy of the Boston Bruins.)

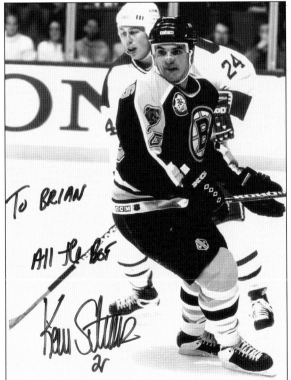

Kevin Stevens. Massachusetts native Kevin Stevens played eight years in Pittsburgh and won two Stanley Cups. His time in Boston was brief, however. He played 41 games in a Bruins uniform before being traded to Los Angeles. He also played for the Rangers and Flyers before returning to the Penguins to finish his career in 2001. (Collection of Brian Codagnone.)

JOE MULLEN. Former Boston College star Joe Mullen was the first American-born player to score 500 goals. The scrappy native of the Hell's Kitchen section of New York City was a veteran of 15 seasons by the time he came to Boston. He played 37 games for the Bruins in 1995–1996 before returning to Pittsburgh to finish his Hall of Fame career. (Courtesy of the Boston Bruins.)

COACH STEVE KASPER. An immensely popular player, Steve Kasper returned to coach the Bruins for two seasons, 1995–1996 and 1996–1997. His tenure included an opening-round playoff defeat by the Florida Panthers in 1996 and, in 1996–1997, the first nonplayoff season for the Bruins since the 1966–1967 season. (Courtesy of the Boston Bruins.)

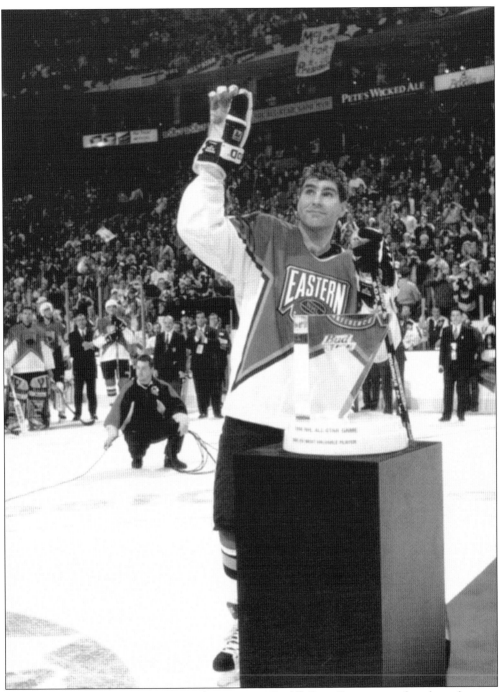

ALL-STAR MVP RAY BOURQUE. The 1996 NHL All-Star Game was played at the new FleetCenter. Fittingly, Ray Bourque scored the winning goal to win it for the Eastern Division. Bourque is shown with the All-Star Game MVP Award. (Collection of Brian Codagnone.)

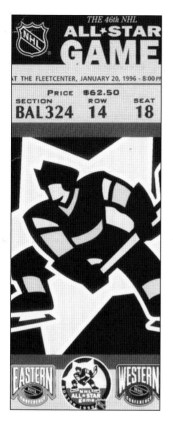

AN ALL-STAR GAME TICKET. The 1996 All-Star Game was Ray Bourque's 14th and included such luminaries as Brian Leetch, Mark Messier, Mario Lemieux, Mats Sundin, Joe Sakic, and Wayne Gretzky. (Collection of Brian Codagnone.)

BILL RANFORD. Bill Ranford returned to Boston after nine seasons, two Stanley Cups, and a Smythe Trophy (1990) in Edmonton. His second tour in black and gold was brief, however. After parts of two seasons, he was traded to Washington with Adam Oates and Rick Tocchet for Jim Carey, Anson Carter, Jason Allison, and draft pick Lee Goren. (Courtesy of the Boston Bruins.)

KYLE MCLAREN. At six feet four inches tall and 225 pounds, Kyle McLaren was a force at the blue line. The Bruins' No. 1 pick in the 1995 entry draft, McLaren was the Seventh Player Award winner and a member of the NHL All-Rookie team in his first season, 1995–1996. (Photograph by Steve Babineau.)

JASON ALLISON. Jason Allison came to Boston in 1997 in the blockbuster trade that sent Adam Oates, Rick Tocchet, and Bill Ranford to Washington for Allison, Jim Carey, and draft pick Lee Goren. He played well in Boston, and on November 8, 2000, he was named the 16th captain in Bruins history. In 2001, he was traded (with Mikko Eloranta) to Los Angeles in the deal that brought Josef Stumpel and Glen Murray back to Boston. (Courtesy of the Boston Bruins.)

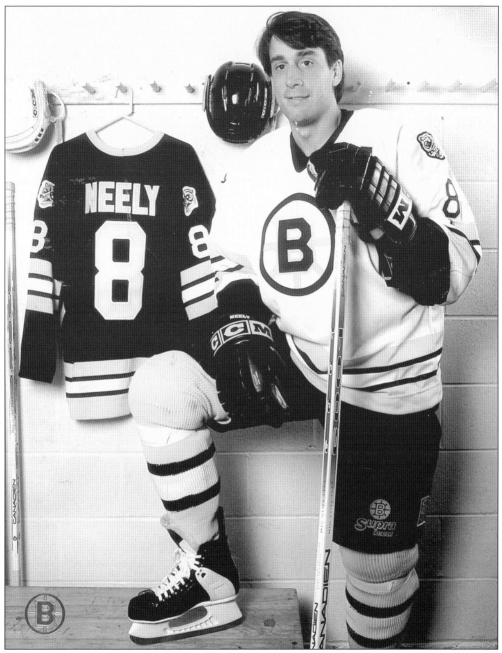

CAM NEELY. Cam Neely played 10 seasons with the Bruins before being forced to retire due to injuries. A three-time 50-goal scorer with a career-high 55 goals in 1988–1990, he won the Masterton Trophy 1994; the Seventh Player Award in 1987; and the Dufresne Award in 1988, 1991, and 1994. Neely was a four-time second team all-star in 1988, 1990, 1991, and 1994. (Photograph by Steve Babineau.)

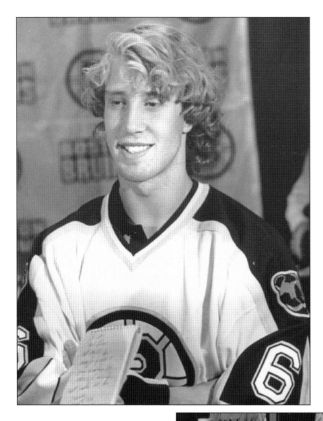

JOE THORNTON. Joe Thornton is seen at the 1997 NHL draft. Thornton was selected as the first overall pick from Sault Ste. Marie of the Ontario Hockey League (OHL). He was soon joined by fellow Bruins first-round pick Sergei Samsonov from the Central Sport Club of Army (CSKA) of Russia (by way of Detroit of the International Hockey League). (Courtesy of the Boston Bruins.)

SERGEI SAMSONOV. Already a veteran at 19, Sergei Samsonov won the Calder Memorial Trophy in 1997–1998. The Moscow native played for the elite Red Army team, Team Russia, in the 1996 and 1997 World Junior Championships, where he won a bronze medal (1997) and led all goal scorers with six goals in six games. Truly an international player, Samsonov speaks three languages (Russian, English, and German). (Photograph by Al Ruelle.)

PAT BURNS. Former policeman Pat Burns was a successful coach in Montreal and Toronto before coming to Boston. The winner of the Jack Adams Award in 1989, 1993, and 1998, he took many teams to the playoffs, but the Stanley Cup eluded him until he coached the Devils in 2003. (Courtesy of the Boston Bruins.)

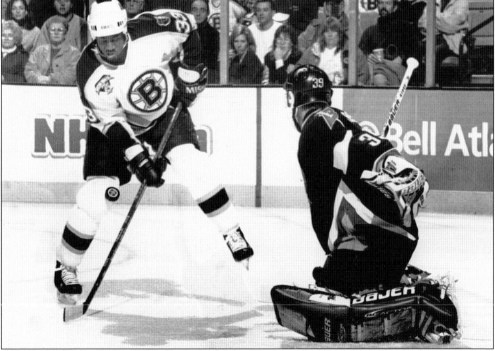

ANSON CARTER. Anson Carter played four years at Michigan State University before turning professional with Washington (although he had originally been a Quebec draft pick). He came to Boston in a multiplayer trade in 1997 and played here until going to Edmonton in the Bill Guerin trade. (Courtesy of the Boston Bruins.)

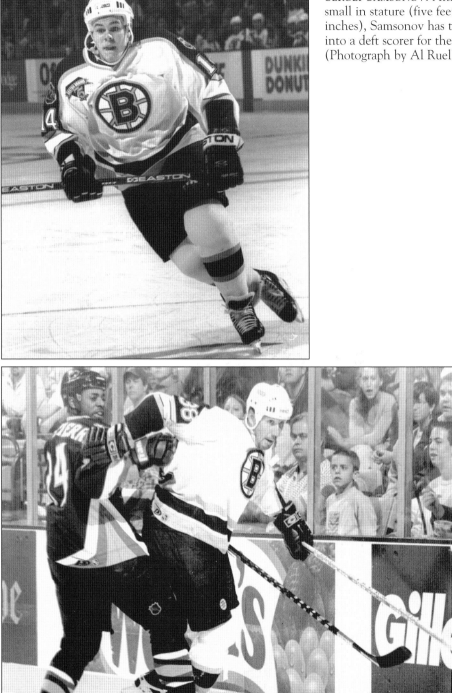

SERGEI SAMSONOV. Although small in stature (five feet eight inches), Samsonov has turned into a deft scorer for the Bruins. (Photograph by Al Ruelle.)

DAVE ANDREYCHUK. Dave Andreychuk went to Colorado with Ray Bourque but moved on to Buffalo before the Avalanche won the Stanley Cup in 2001. A veteran of 17 seasons with Buffalo, Toronto, and New Jersey, Andreychuk played in All-Star Games in 1990 and 1994. (Courtesy of the Boston Bruins.)

Five

2000–PRESENT

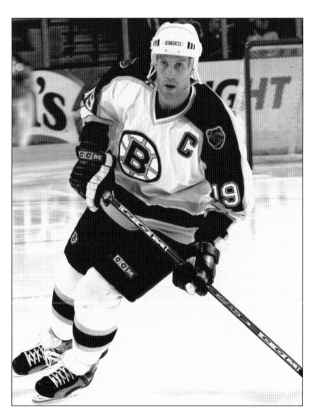

JOE THORNTON. Joe Thornton was the Bruins' first pick, first overall, in the 1997 entry draft. Before coming to Boston, he played for the Sault Ste. Marie Greyhounds and was the youngest member of the Canadian team that won the gold medal at the 1997 World Junior Championships. Since his rookie season, Thornton has blossomed not only into a scorer but also a leader, and currently wears the captain's C. (Courtesy of the Boston Bruins.)

PAUL COFFEY. Paul Coffey was a veteran of 20 NHL seasons and winner of four Stanley Cups when he came to Boston as a free agent. He had played on the great Edmonton teams of the Gretzky years and was a premier blue liner and perennial all-star, but by 2000, his best years were clearly behind him. He was released after less than a season. (Courtesy of the Boston Bruins.)

HAL GILL. At six feet seven inches, defenseman Hal Gill is one of the tallest players ever to wear an NHL uniform. A true local product, the Massachusetts native played four years at Providence College before being drafted by the Bruins. (Courtesy of the Boston Bruins.)

BYRON DAFOE. Byron Dafoe came to Boston from Los Angeles in 1997 along with Dimitri Khristich for Josef Stumpel and Sandy Moger. "Lord Byron" quickly established himself as a premier NHL goaltender. (Courtesy of the Boston Bruins.)

MIKE KEENAN. "Iron Mike" was brought in to replace Pat Burns behind the bench in the 2000–2001 season. The veteran coach, who piloted Philadelphia, Chicago, New York (where he won a Stanley Cup in 1994), St. Louis, and Vancouver was a no-nonsense disciplinarian who ran his team like a drill sergeant. He coached one season in Boston before moving on to Florida. (Courtesy of the Boston Bruins.)

MIKE KNUBLE. Mike Knuble set an NHL record by scoring the fastest two goals from the start of a game by a single player, with scores at 0:10 and 0:27 of the first period, on February 14, 2003, in Florida against the Panthers. The previous record was 33 seconds by Chicago's John Marks on November 13, 1975, at Philadelphia. Knuble scored at 0:14 and 0:33. The Bruins went on to beat the Panthers in overtime by a score of 6-5. Mike Knuble was the 2003 recipient of the annual Seventh Player Award, voted on by the fans, as well as the Eddie Shore Award, which has been presented annually by the Gallery Gods since 1937 and is given to the player that they feel "exhibits exceptional hustle and determination." (Courtesy of the Boston Bruins.)

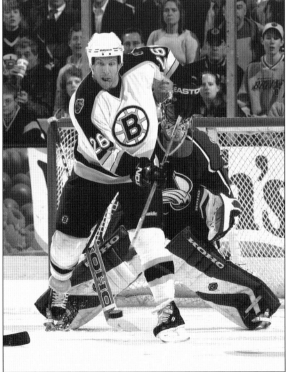

120

ROBBIE FTOREK. Robbie Ftorek of Needham was perhaps the most stylish and dynamic schoolboy hockey player ever to compete in the state of Massachusetts. He won an Olympic silver medal in 1972 and played professionally for the Red Wings, Nordiques, and Rangers of the NHL, as well as Phoenix and Cincinnati of the World Hockey Association. He coached the Kings and Devils before coming to the Bruins in the 2001–2002 season. He coached the team until 2003. (Courtesy of the Boston Bruins.)

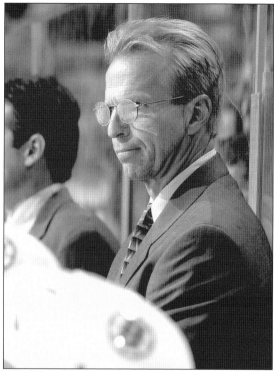

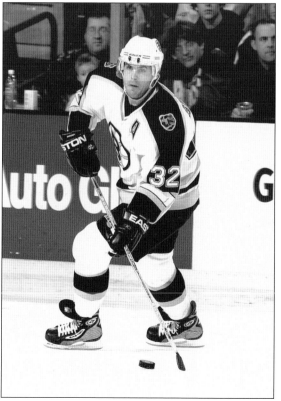

DON SWEENEY. A consistent player and hard checker, Harvard graduate Don Sweeney may be one of the most underrated defensemen in the NHL. (Courtesy of the Boston Bruins.)

121

BILL GUERIN. Bill Guerin was already an established star when he came to Boston from Edmonton. The Massachusetts native played for Team USA in both the 1989 and 1990 World Junior Championships, the 1996 World Cup, and the 1998 Olympics. Drafted by New Jersey in 1989, he was a member of the 1995 Devils Stanley Cup championship team. (Courtesy of the Boston Bruins.)

BRIAN ROLSTON. Like Bill Guerin, Brian Rolston played for Team USA before being being drafted by New Jersey. Rolston has the distinction of being traded (along with Sammy Pahlsson and Martin Grenier) from Colorado for Ray Bourque and Dave Andreychuk. (Courtesy of the Boston Bruins.)

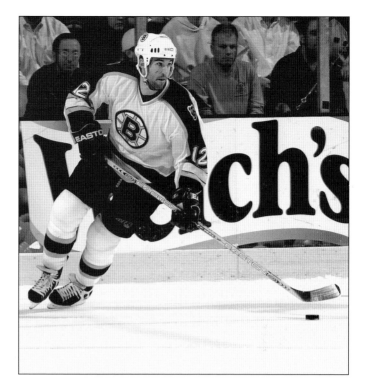

P.J. AXELSSON. A native of Kungalv, Sweden, P.J. Axelsson played for Frolunda Goteborg of the Swedish Elite League (as well as Team Sweden in the World Championships) before coming to Boston. The durable left wing is one of the best defensive forwards in the NHL. (Courtesy of the Boston Bruins.)

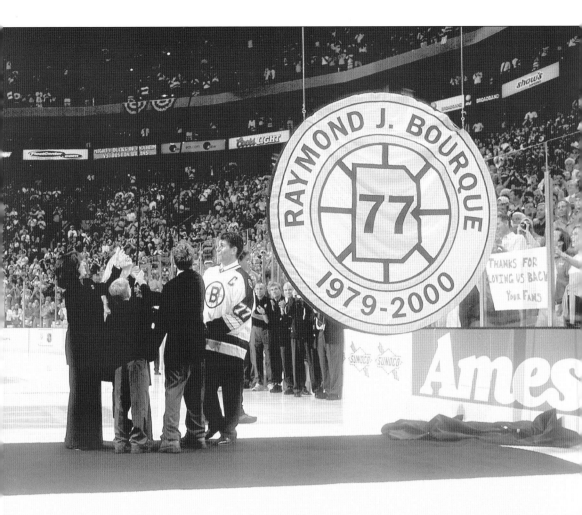

No. 77 Goes to the Rafters. On opening night in 2001, Ray Bourque was honored by having his number raised to the rafters to join the other Bruin immortals. He began his career wearing No. 7 but gave it up so it could be retired for Phil Esposito. He has the distinction of being the only one of this elite group (Eddie Shore, Lionel Hitchman, Bobby Orr, Dit Clapper, Phil Esposito, John Bucyk, and Milt Schmidt) to be the only player to ever wear his number. Terry O'Reilly's No. 24 would later join the banners in the rafters. (Photograph by Al Ruelle.)

MARTIN LAPOINTE. Martin Lapointe came to Boston after spending his entire professional career in the Detroit organization, where he won Stanley Cups in 1997 and 1998. A power forward in the Cam Neely mold, Lapointe is as solid a hitter as he is a scorer. (Courtesy of the Boston Bruins.)

JEREMY JACOBS. Chairman and chief executive officer of Delaware North Companies, Jeremy Jacobs has had an influence on Boston beyond his nearly 30-year ownership of the Bruins. It was his vision and determination that made the privately financed FleetCenter a reality in 1995. A state-of-the-art home for the Bruins and Celtics, the facility has attracted many prestigious events to the city, including the NCAA Hockey Frozen Four, the Olympic gymnastics trials in 1996 and 2000, and the 2004 Democratic National Convention. (Courtesy of the Boston Bruins.)

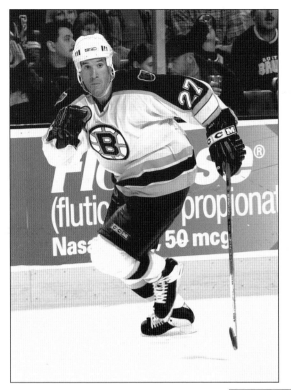

GLEN MURRAY. Glen Murray has had two tours in Boston. He was the Bruins' first pick in the 1991 entry draft but was traded to Pittsburgh in 1995. After playing in Pittsburgh and Los Angeles, he was traded back to Boston in 2001, where he has enjoyed the best hockey of his career. (Courtesy of the Boston Bruins.)

P.J. STOCK. Not very big, not a high scorer, but a tough, scrappy player, P.J. Stock is best known for the wave he gives to fans after his many fights. He is one of the most popular Bruins, and black-and-gold "P.J." T-shirts fill the stands on any given night at the FleetCenter. (Courtesy of the Boston Bruins.)

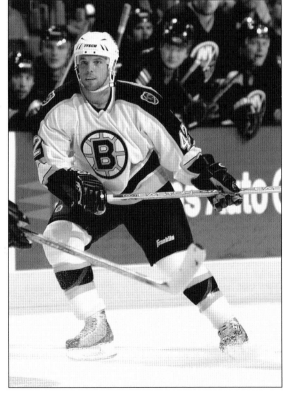

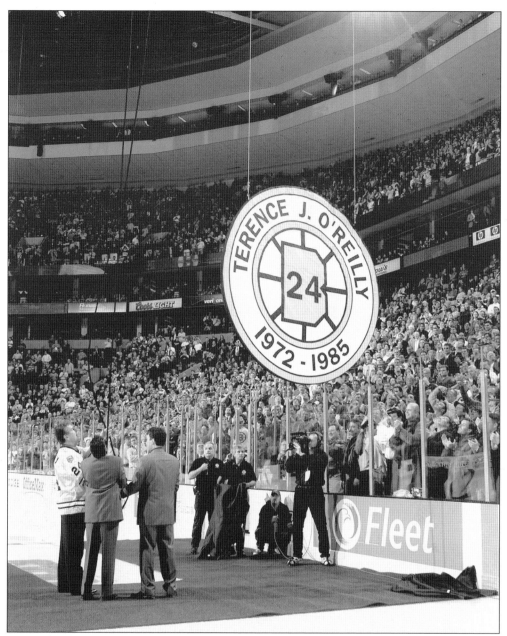

TERRY O'REILLY NUMBER RETIREMENT NIGHT, OCTOBER 24, 2002. One of the most popular Bruins of all time, Terry O'Reilly watches as his number is hoisted to the rafters. The personification of the lunchpail Bruins' work ethic, O'Reilly worked hard, led by example, and never backed down from a fight. He brought that same attitude to coaching, guiding the Bruins for three seasons (from 1986 to 1989), including a Stanley Cup finals appearance in 1988. (Photograph by Al Ruelle.)

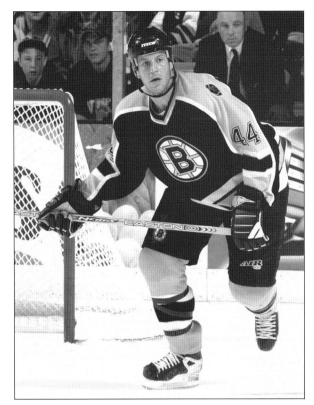

NICK BOYNTON. Nick Boynton was originally chosen by Washington in the 1997 entry draft but was unsigned and reentered the draft. He was Boston's first pick in 1999. A product of Ottawa of the OHL, he captained the 67's to the Memorial Cup championship in 1999, where he was named MVP. The big defenseman was named to the NHL All-Rookie team in 2002. (Courtesy of the Boston Bruins.)

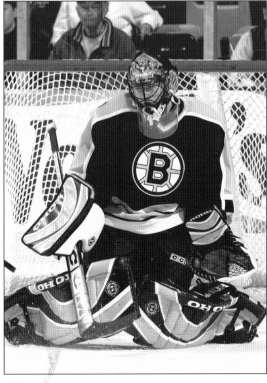

ANDREW RAYCROFT. The OHL's MVP in 1999–2000 (the first goaltender in 50 years to earn that honor), Andrew Raycroft was also named the top goaltender in all of the Canadian major junior leagues that season. Selected by the Bruins in the 1998 NHL entry draft, he became the youngest goaltender, at 20 years old, to win a game in a Boston uniform since March 29, 1986 (Bill Ranford, 19 years old). Young players like Raycroft represent the future of this venerable franchise. (Courtesy of the Boston Bruins.)